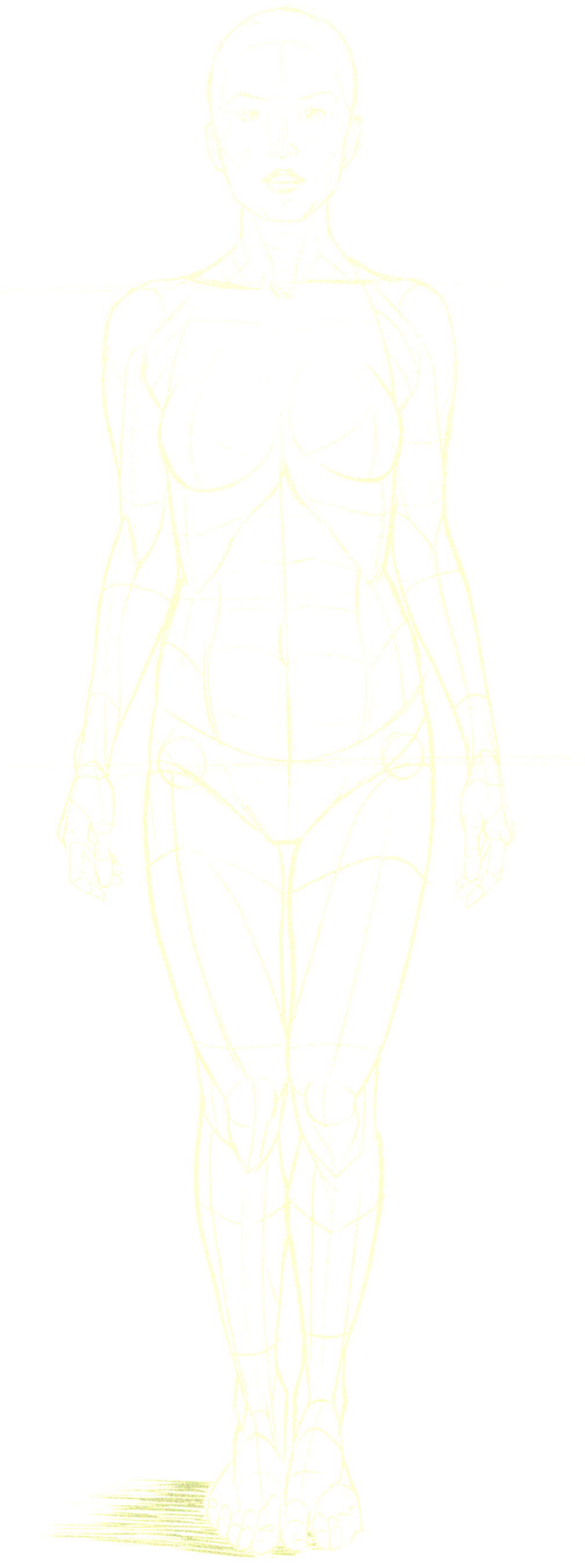

Original Character Workbook VOL 1

Published by Eagle Ink Factory/ Justin Martin © 2016 Justin Martin.

All Rights Reserved. No part of this book may be reproduced, stored in a retreival system or transmitted in any other form or by means electronic (including internet websites), mechanical, photocopying, recording, or in any other form or by any other means, without prior written permission from the publisher or copyright holder(s).

special thanks to Sergio Aragones, Terri Martin, Tavin Martin, Sarah Martin, August Tarantino and Paul Roberts

P.O. Box 2105
Edwards, CO
81632

POSEmuse.com

First Edition, 2016

TABLE of CHARACTERS

CREATOR:

Character/Chapter 01:

Character/Chapter 02:

Character/Chapter 03:

Character/Chapter 04:

Character/Chapter 05:

Character/Chapter 06:

Character/Chapter 07:

Character/Chapter 08:

Character/Chapter 09:

Character/Chapter 10:

TABLE of CHARACTERS cont.

Character/Chapter 11:

Character/Chapter 12:

Character/Chapter 13:

Character/Chapter 14:

Character/Chapter 15:

Character/Chapter 16:

Character/Chapter 17:

Character/Chapter 18:

Character/Chapter 19:

Character/Chapter 20:

01 NAME:
Details:

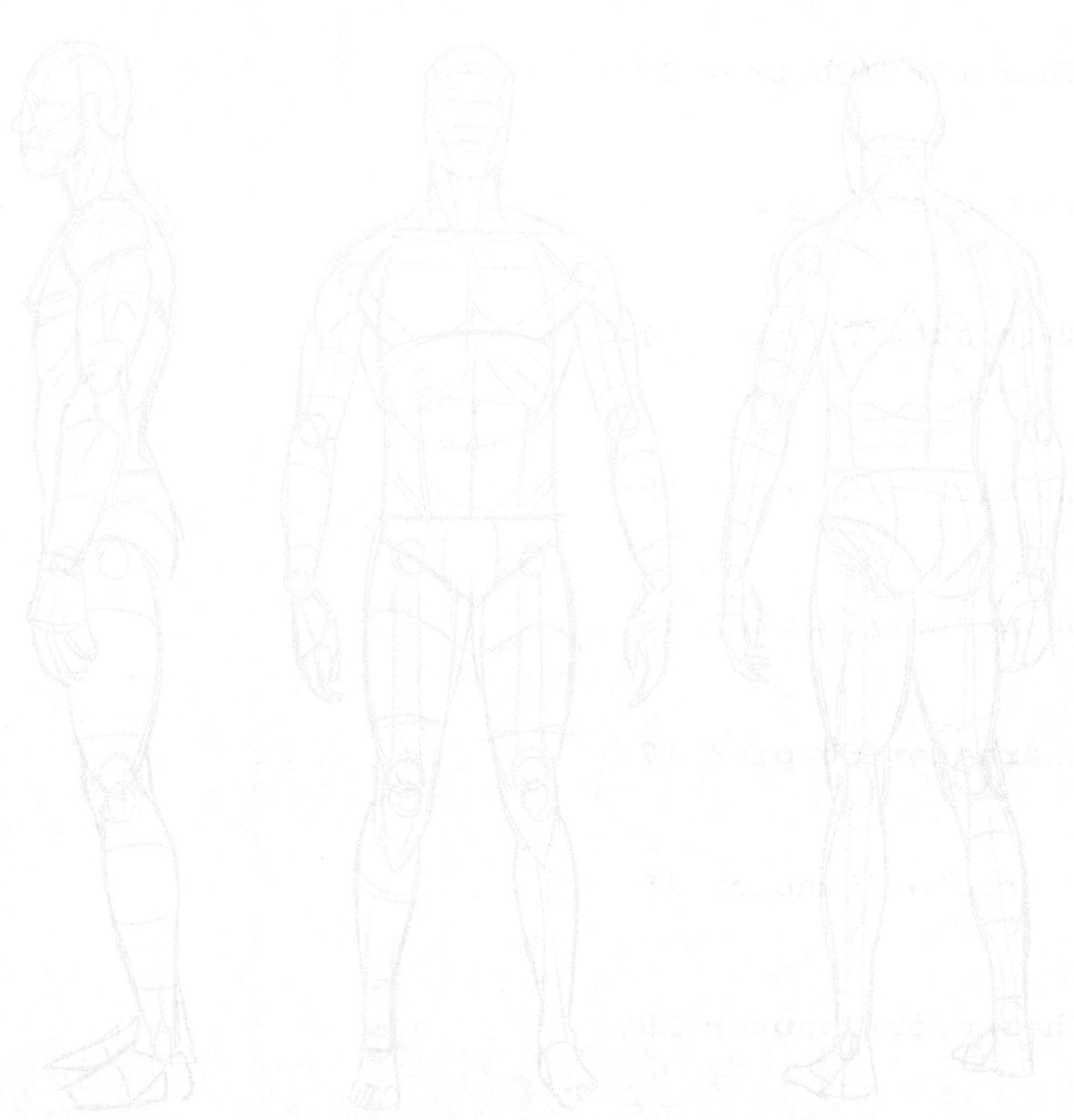

NAME:

Backstory summary

NAME:

Interesting ideas:

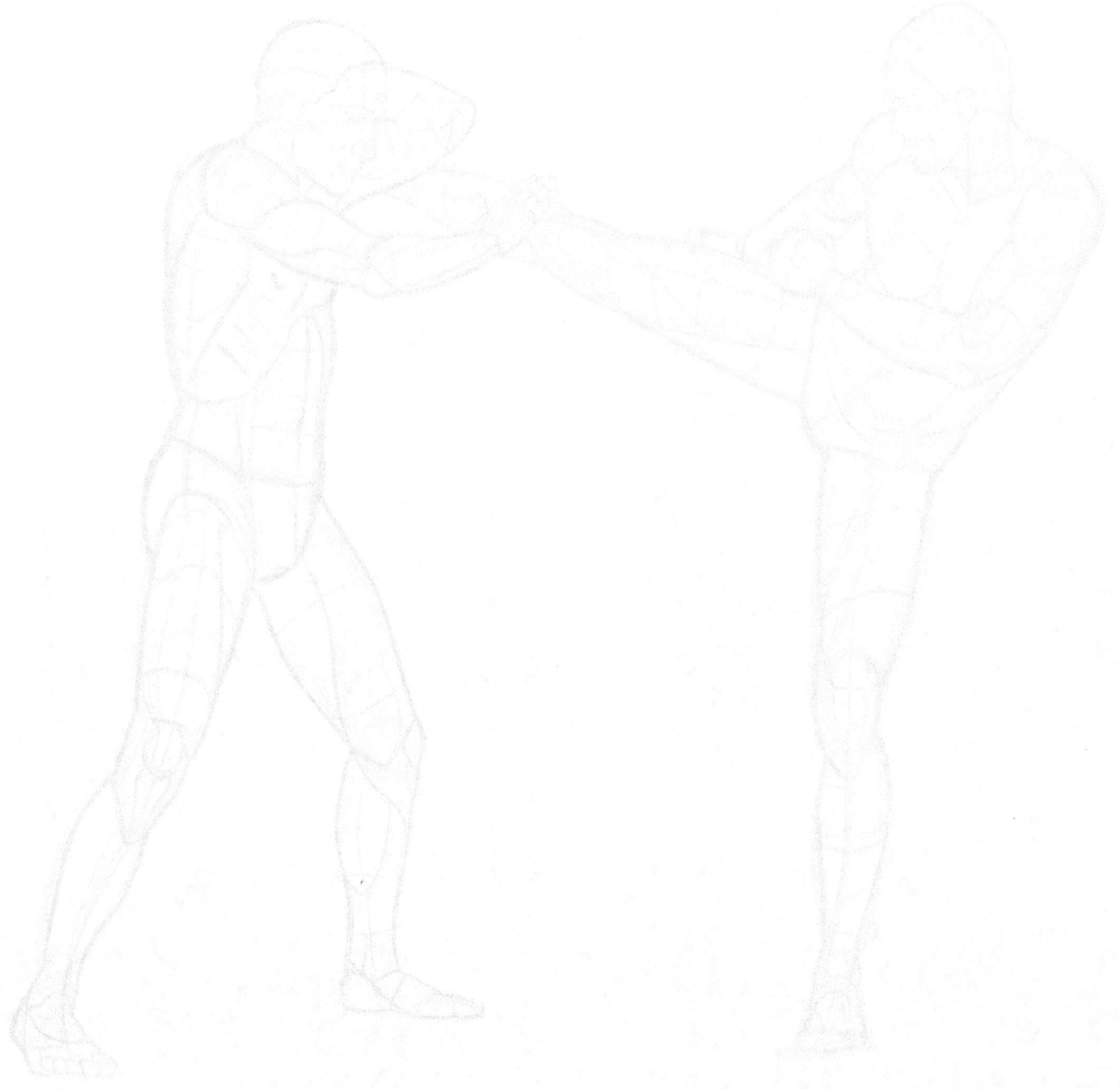

NAME:

NOTES:

NAME:

NAME :

SUMMARY AND CONCLUSIONS:

This character is...

This character dreams...

This character loves...

This character fears...

NAME:

02 NAME:
Details:

NAME:

Backstory summary

NAME:

Interesting ideas:

NAME:

NOTES:

NAME:

NAME:

SUMMARY AND CONCLUSIONS:

This character is...

This character dreams...

This character loves...

This character fears...

NAME:

03 NAME:
Details:

NAME:

Backstory summary

NAME:

Interesting ideas:

NAME:

NOTES:

NAME:

NAME :

SUMMARY AND CONCLUSIONS:

This character is...

This character dreams...

This character loves...

This character fears...

NAME:

04 NAME:
Details:

NAME:

Backstory summary

NAME:

Interesting ideas:

NAME:

NOTES:

NAME:

NAME :

SUMMARY AND CONCLUSIONS:

This character is...

This character dreams...

This character loves...

This character fears...

NAME:

05 NAME:
Details:

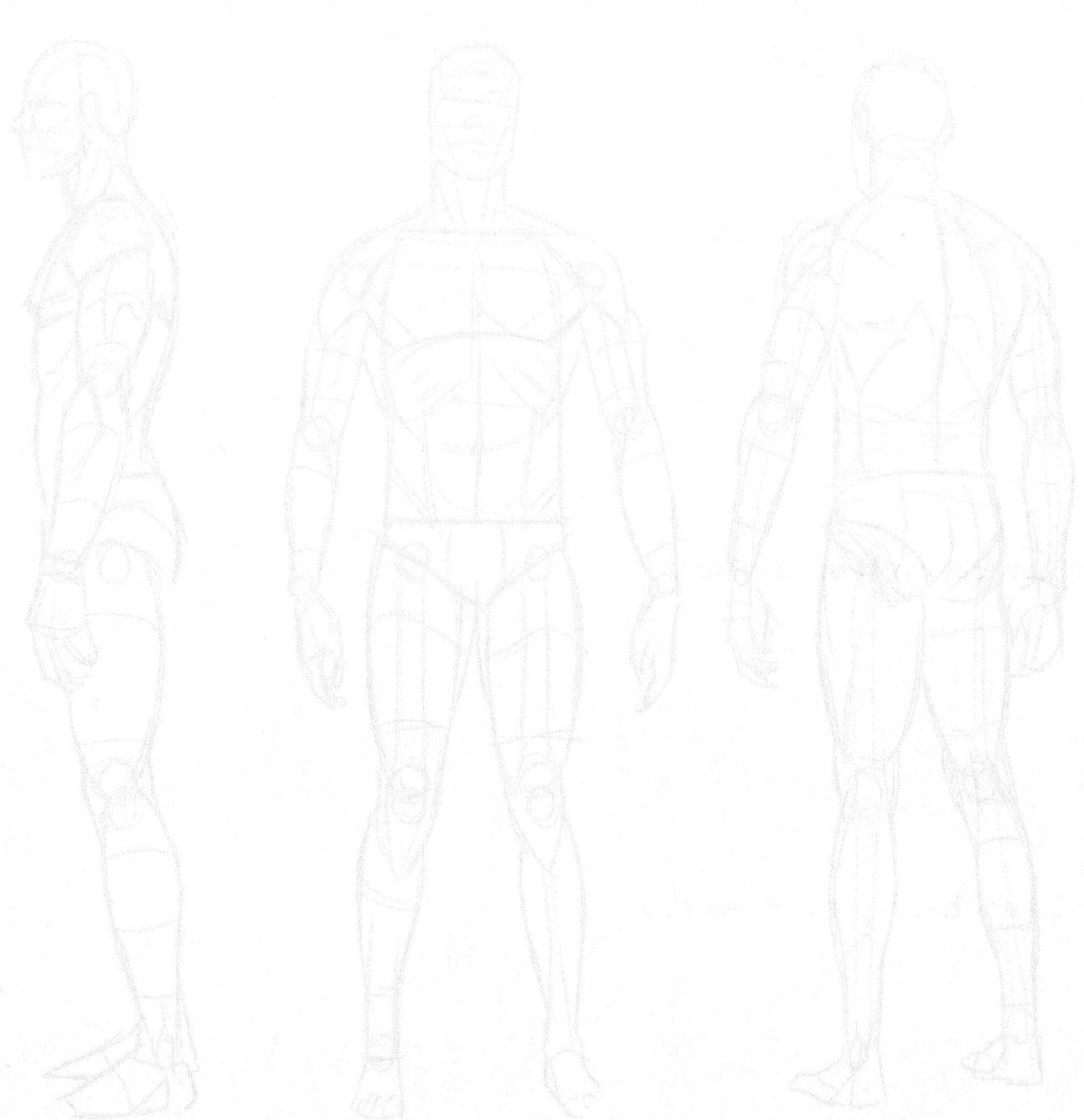

NAME:

Backstory summary

NAME:

Interesting ideas:

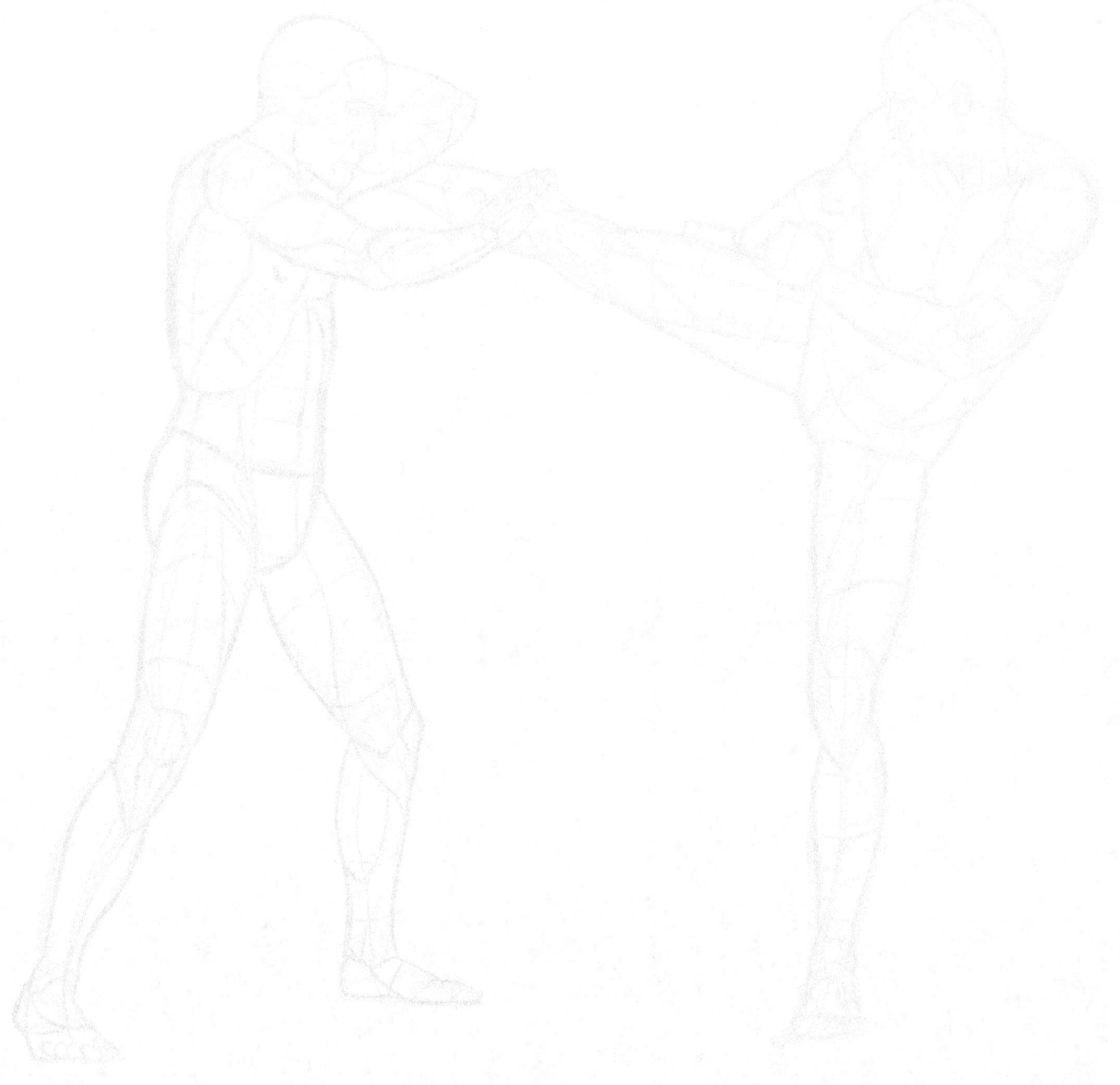

NAME:

NAME :

NOTES:

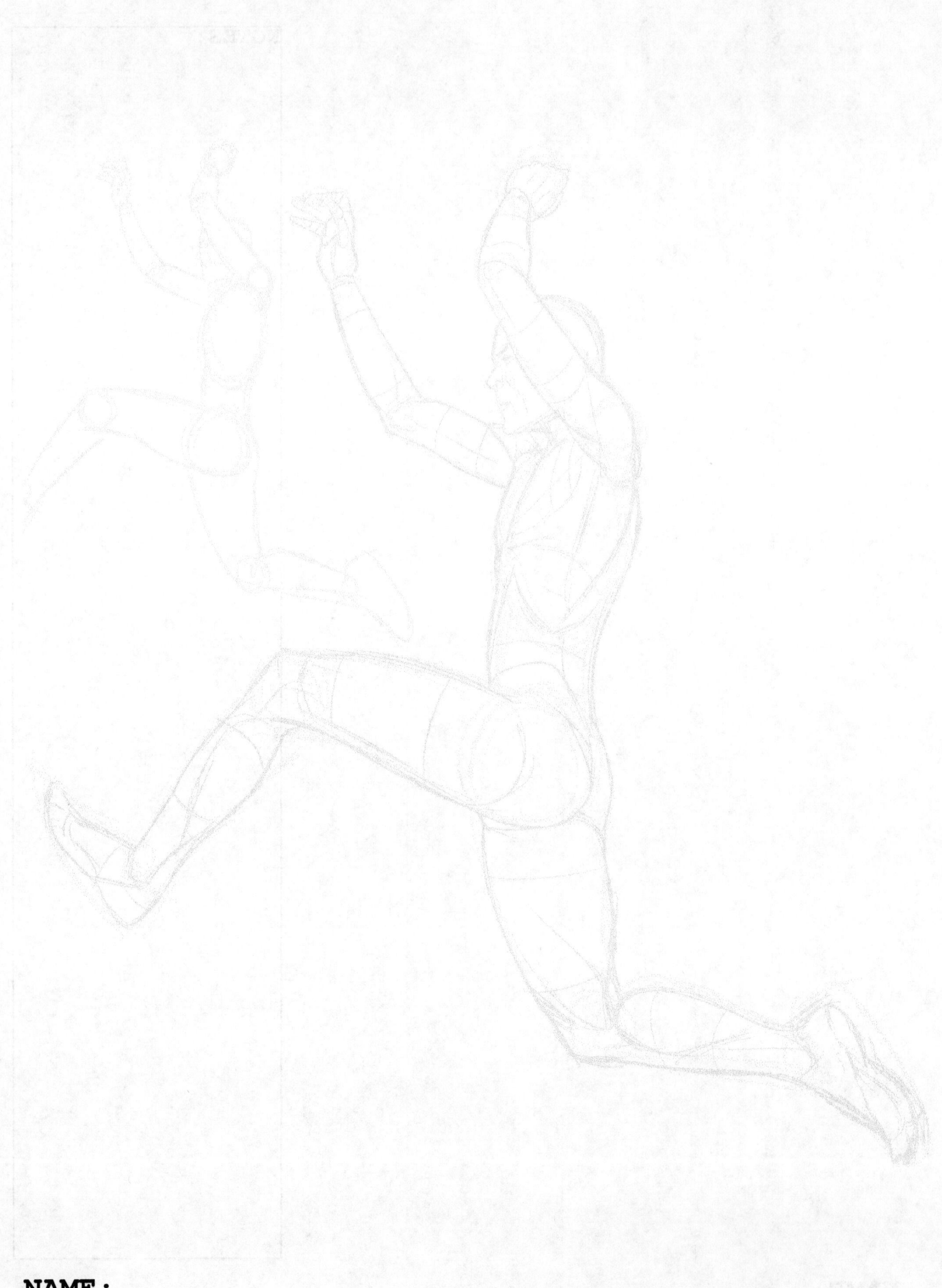

NAME :

SUMMARY AND CONCLUSIONS:

This character is...

This character dreams...

This character loves...

This character fears...

NAME:

```
06 NAME:
Details:
```

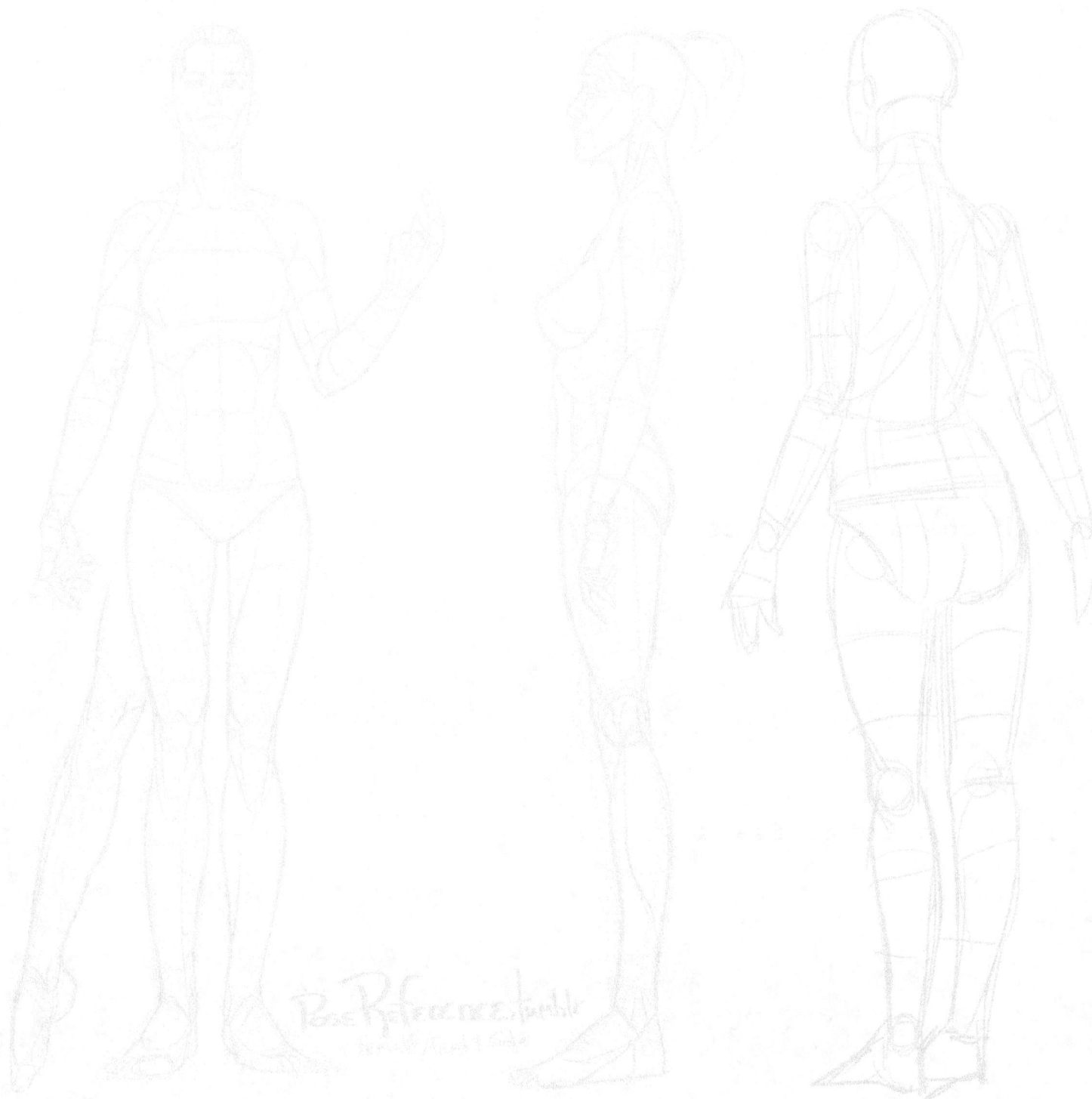

```
NAME:
```

```
Backstory summary
```

NAME :

Interesting ideas:

NAME:

NOTES:

NAME :

NAME :

SUMMARY AND CONCLUSIONS:

This character is...

This character dreams...

This character loves...

This character fears...

NAME:

```
07 NAME:
Details:
```

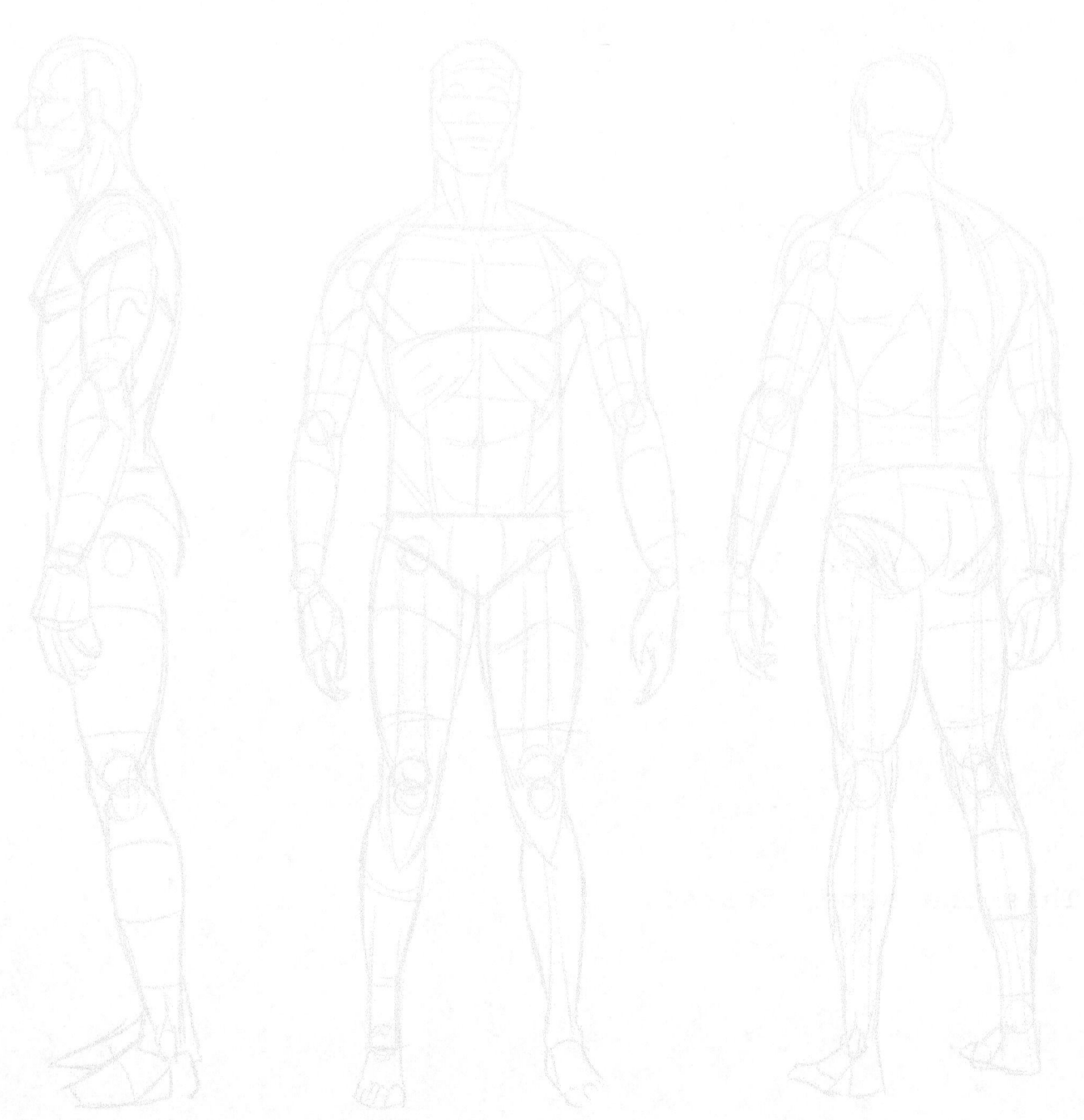

```
NAME:
```

Backstory summary

NAME:

Interesting ideas:

NAME:

NAME:

NOTES:

NAME:

NAME :

SUMMARY AND CONCLUSIONS:

This character is...

This character dreams...

This character loves...

This character fears...

NAME:

08 NAME:
Details:

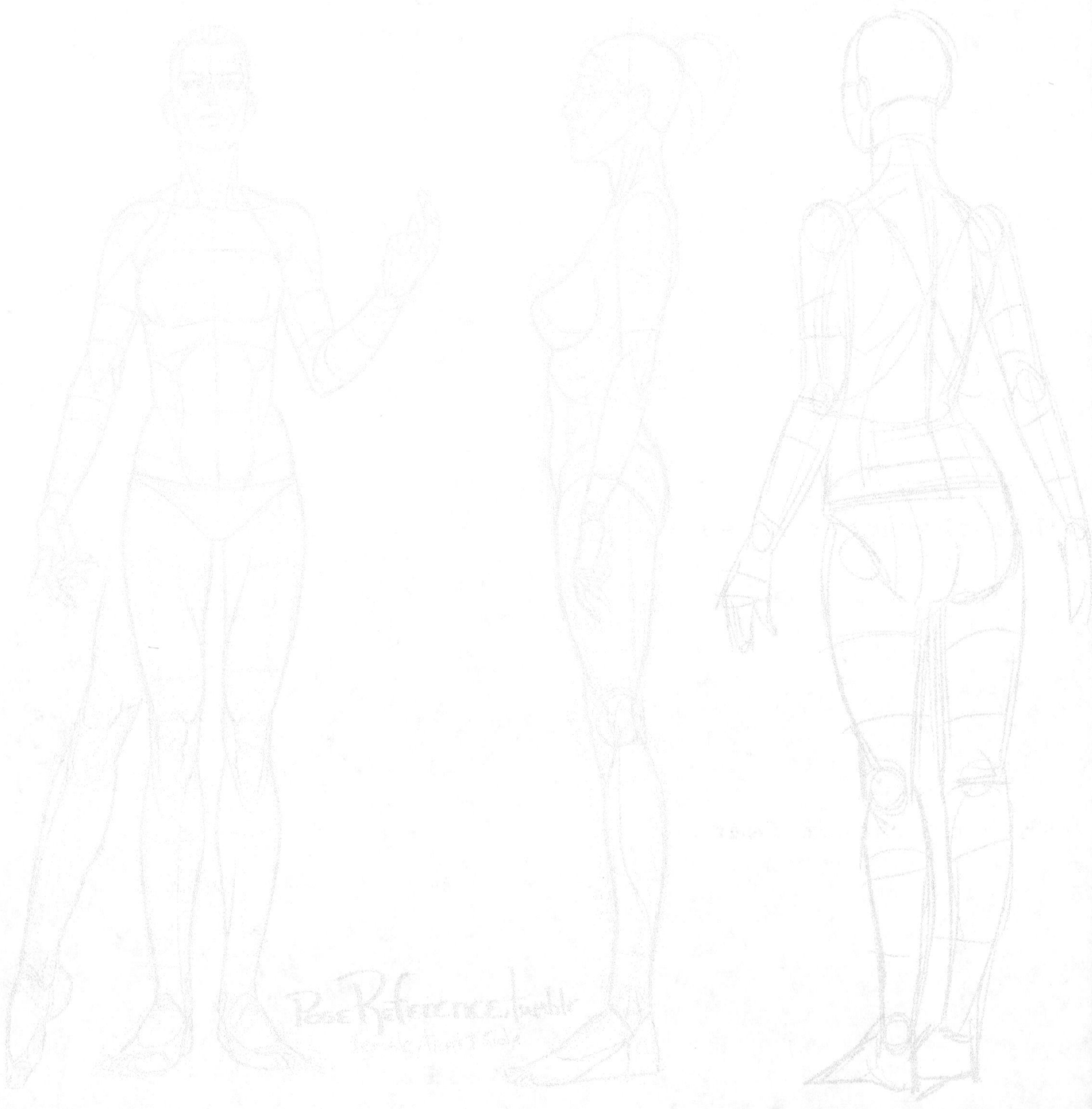

NAME:

Backstory summary

NAME:

Interesting ideas:

NAME:

NOTES:

NAME :

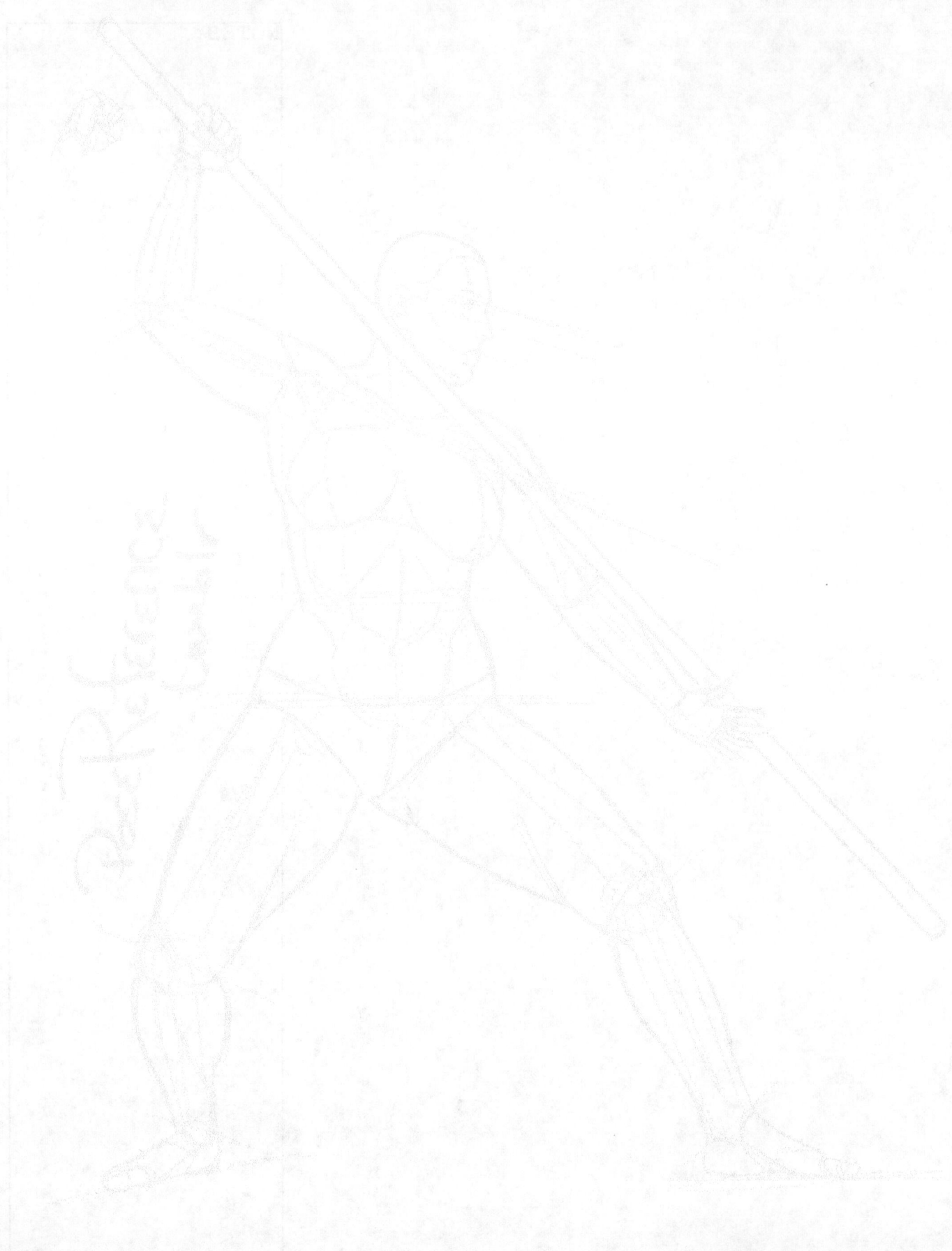

NAME :

SUMMARY AND CONCLUSIONS:

This character is...

This character dreams...

This character loves...

This character fears...

NAME:

09 NAME:
Details:

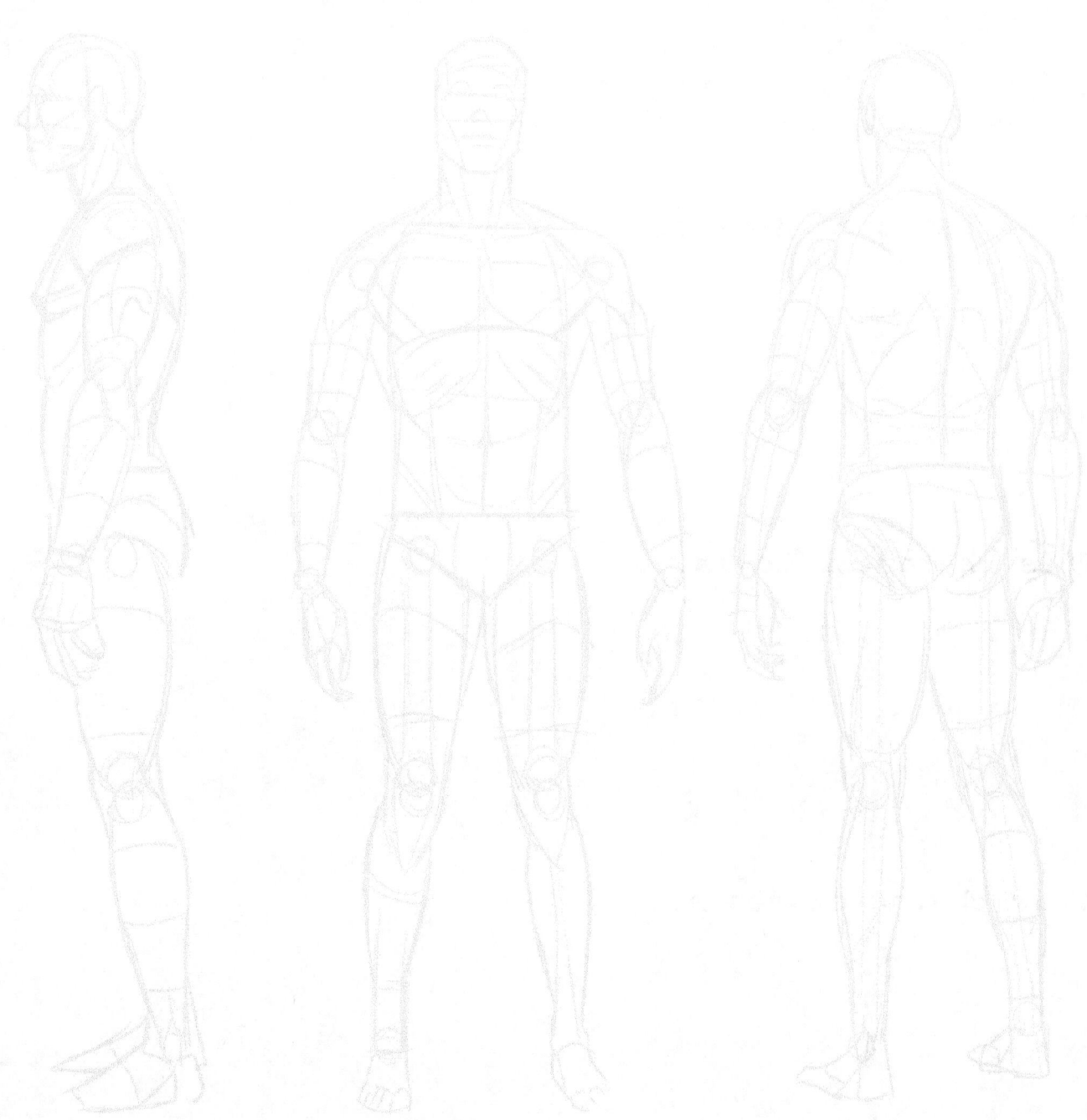

09 NAME:
NAME:

Backstory summary

NAME:

Interesting ideas:

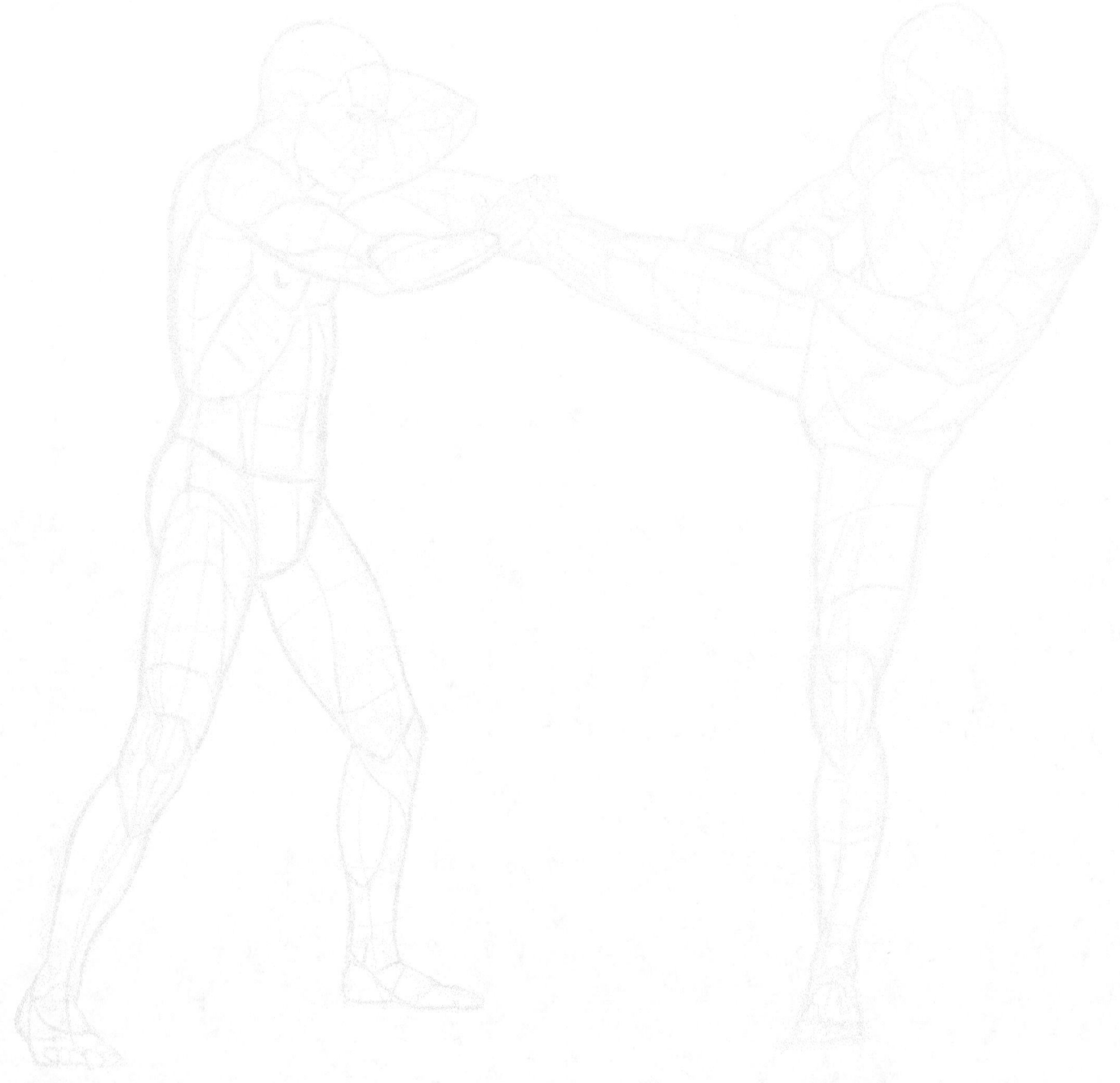

NAME:

NOTES:

NAME:

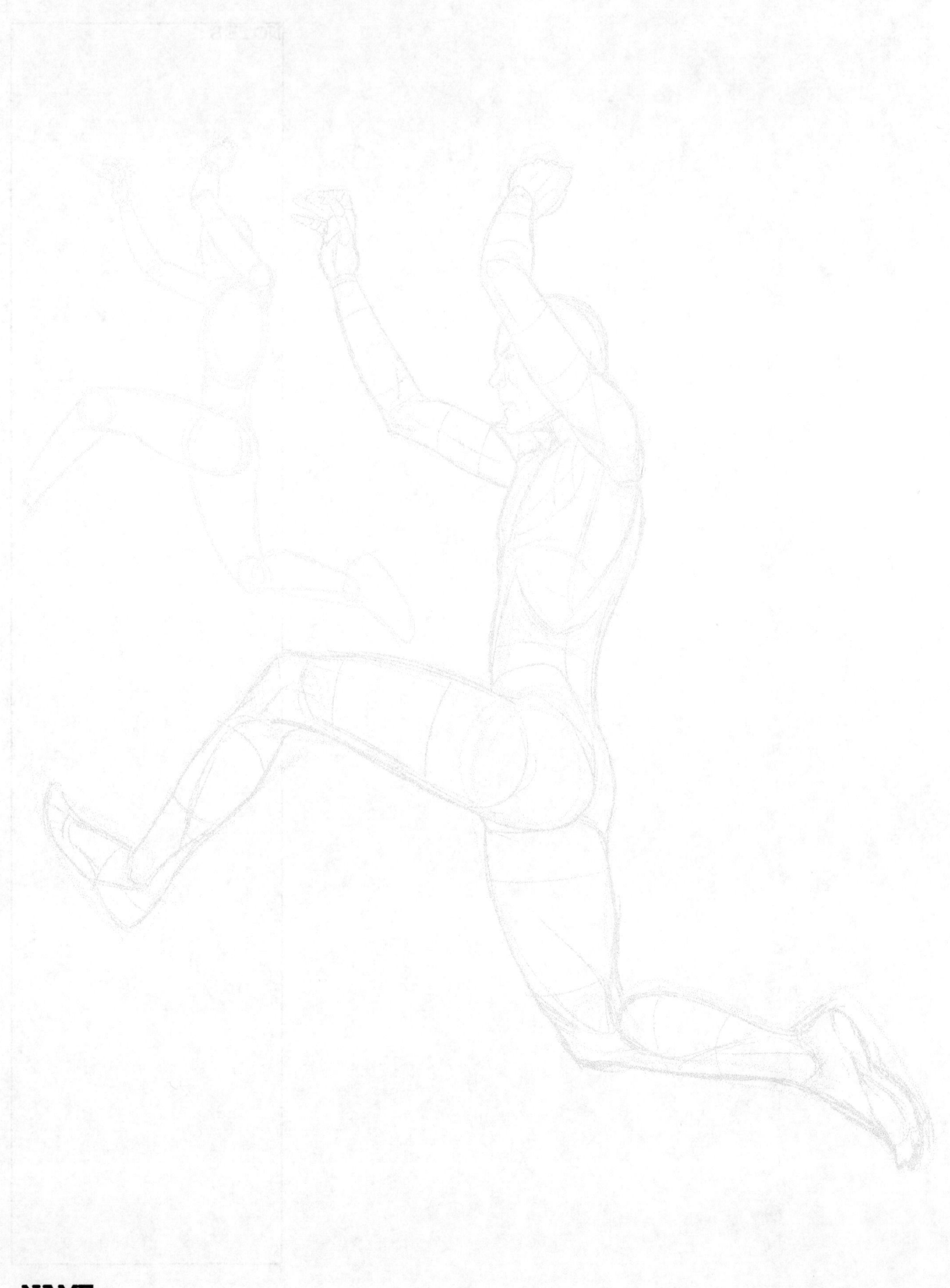

NAME :

SUMMARY AND CONCLUSIONS:

This character is...

This character dreams...

This character loves...

This character fears...

NAME:

10 NAME:
Details:

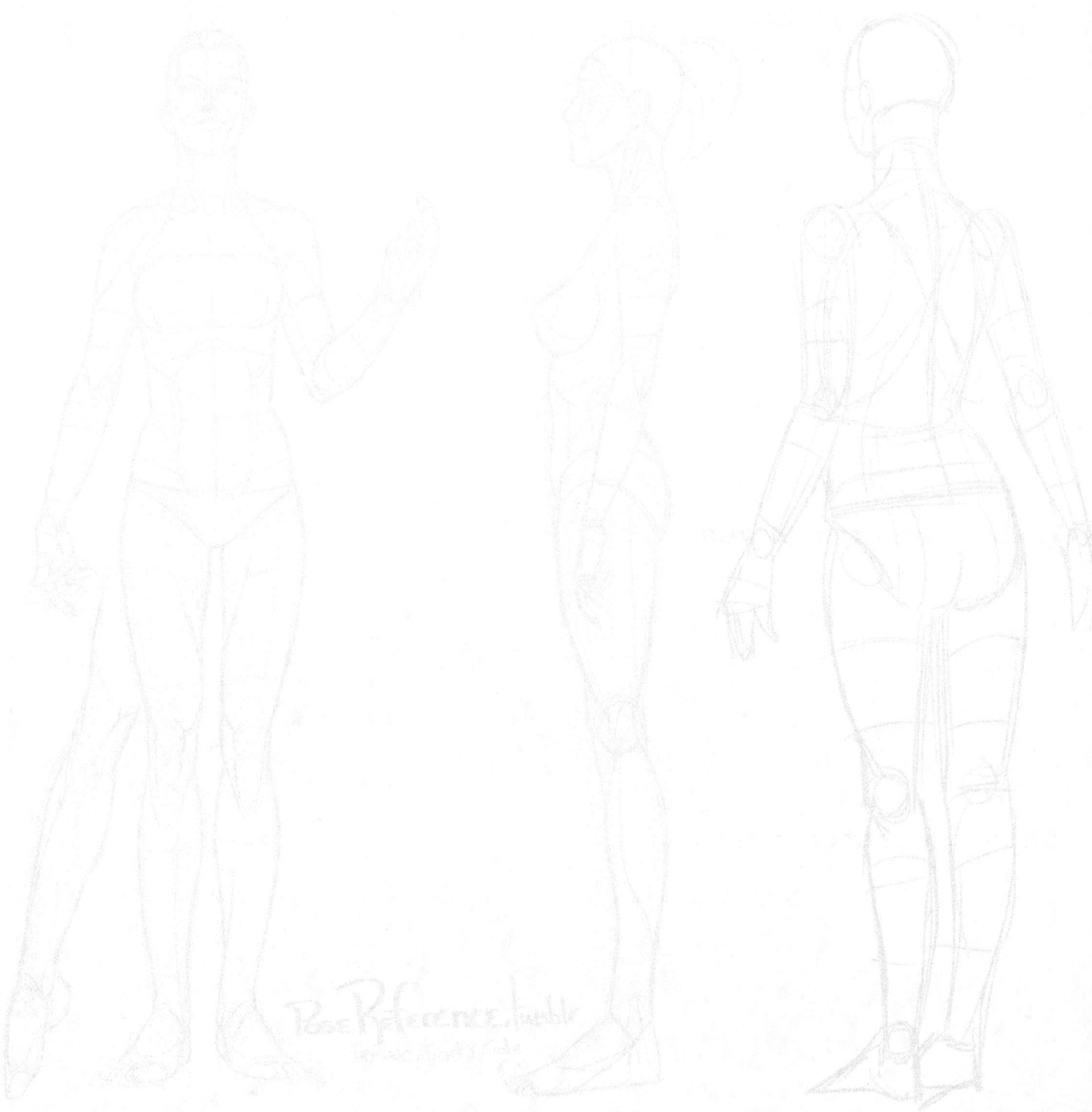

NAME:

Backstory summary

NAME:

Interesting ideas:

NAME:

NOTES:

NAME:

NAME :

SUMMARY AND CONCLUSIONS:

This character is...

This character dreams...

This character loves...

This character fears...

NAME:

11 NAME:
Details:

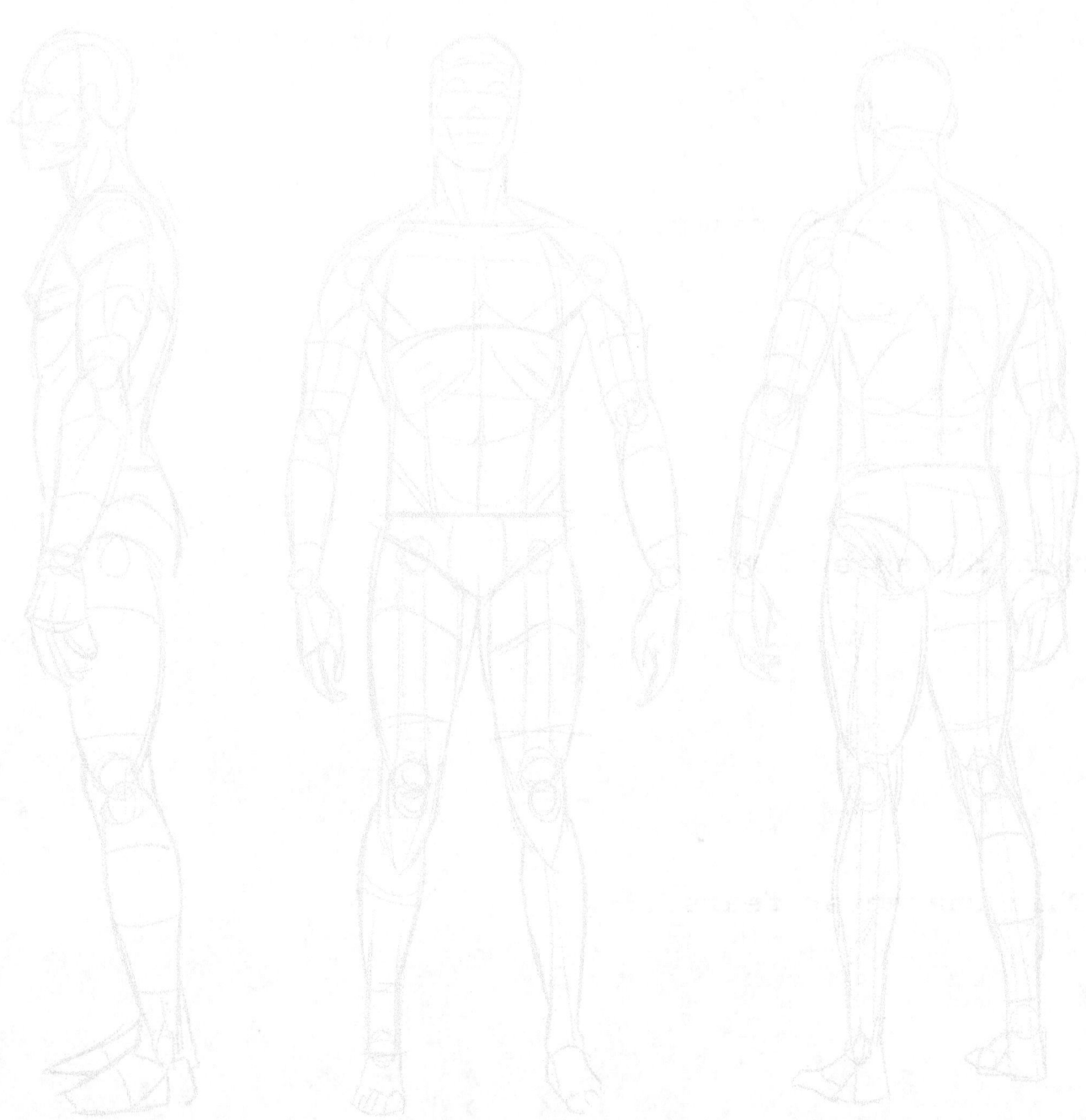

NAME:

Backstory summary

NAME:

Interesting ideas:

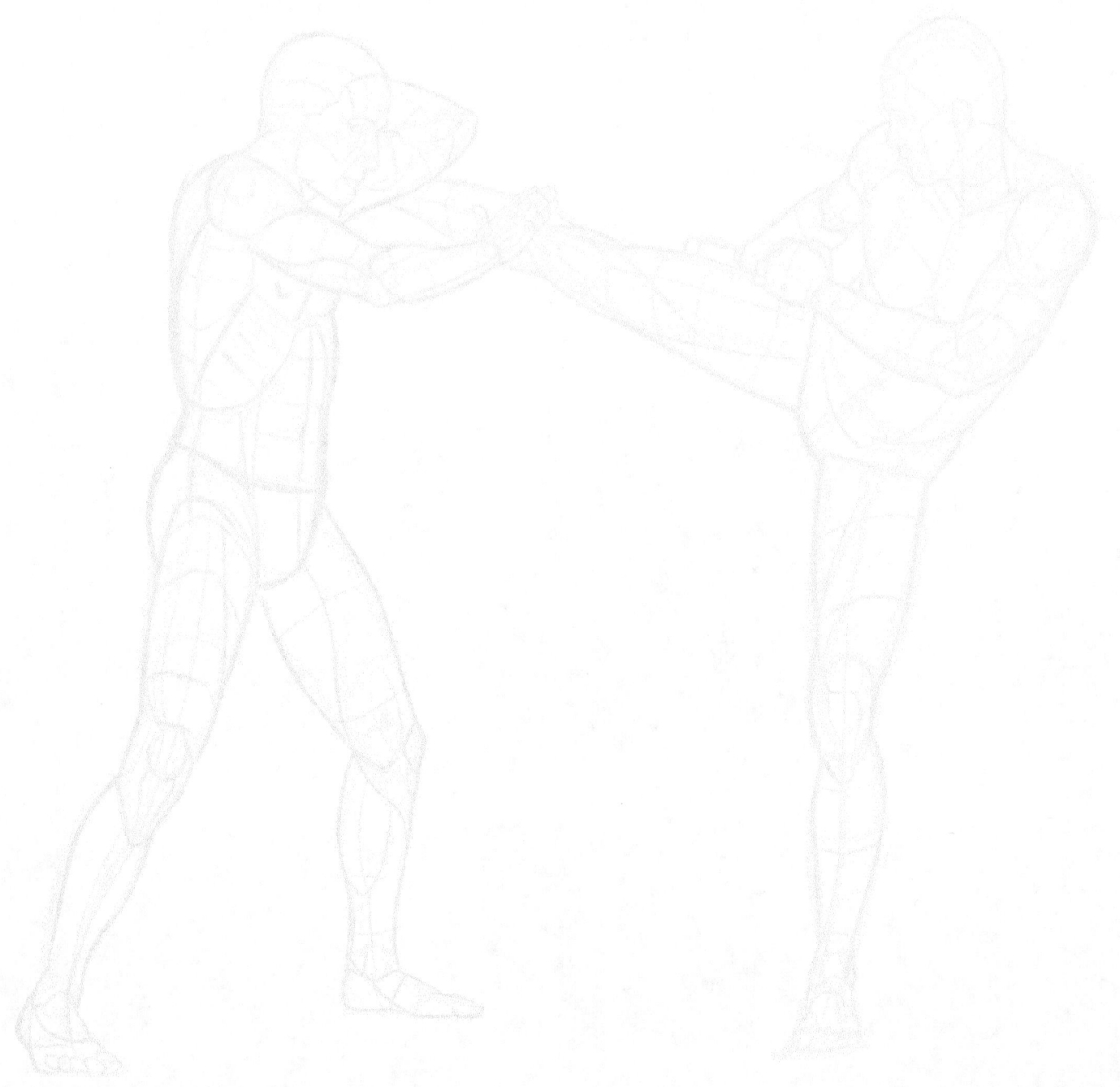

NAME:

NOTES:

NAME:

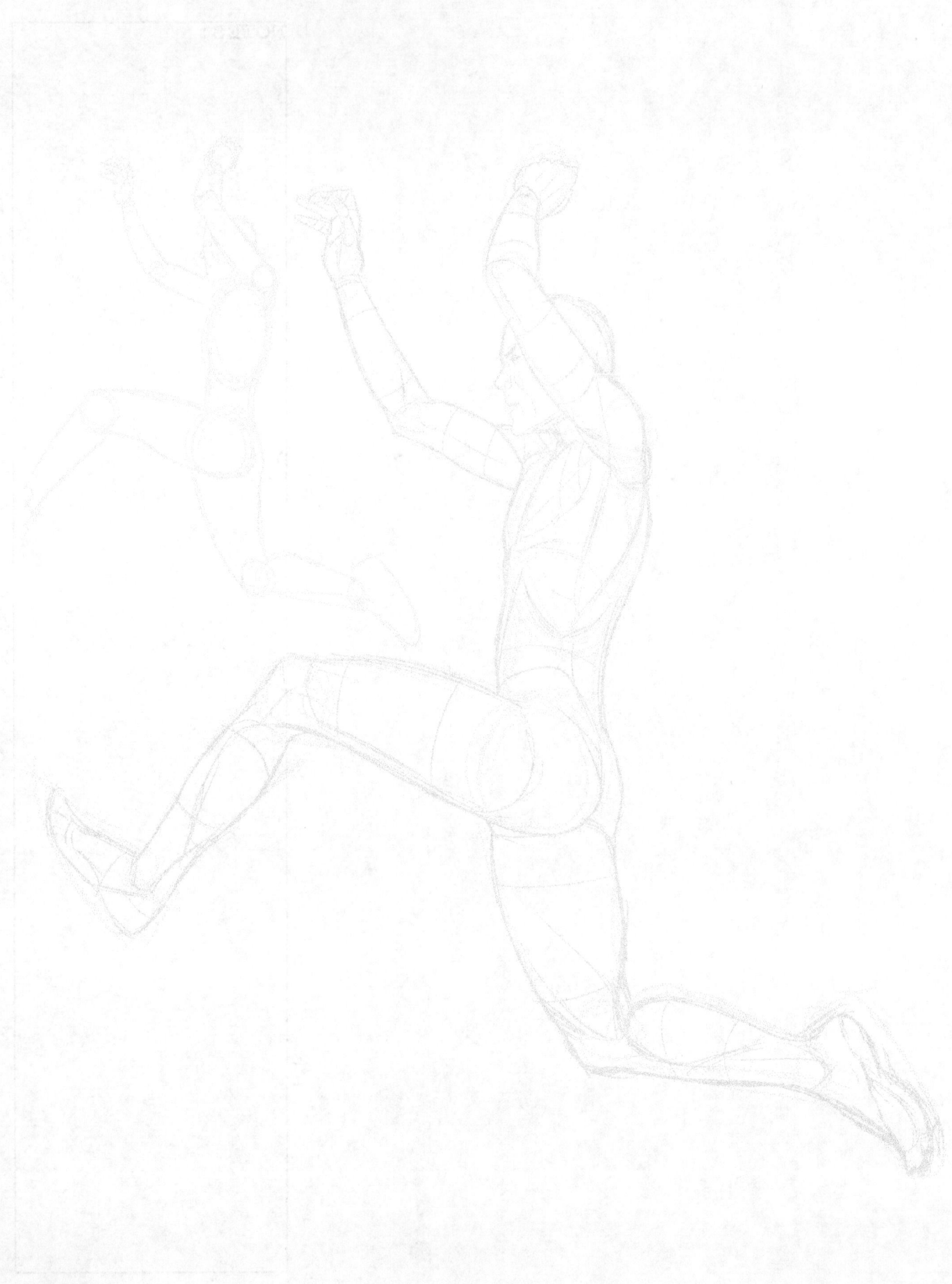

NAME :

SUMMARY AND CONCLUSIONS:

This character is...

This character dreams...

This character loves...

This character fears...

NAME:

```
12 NAME:
Details:
```

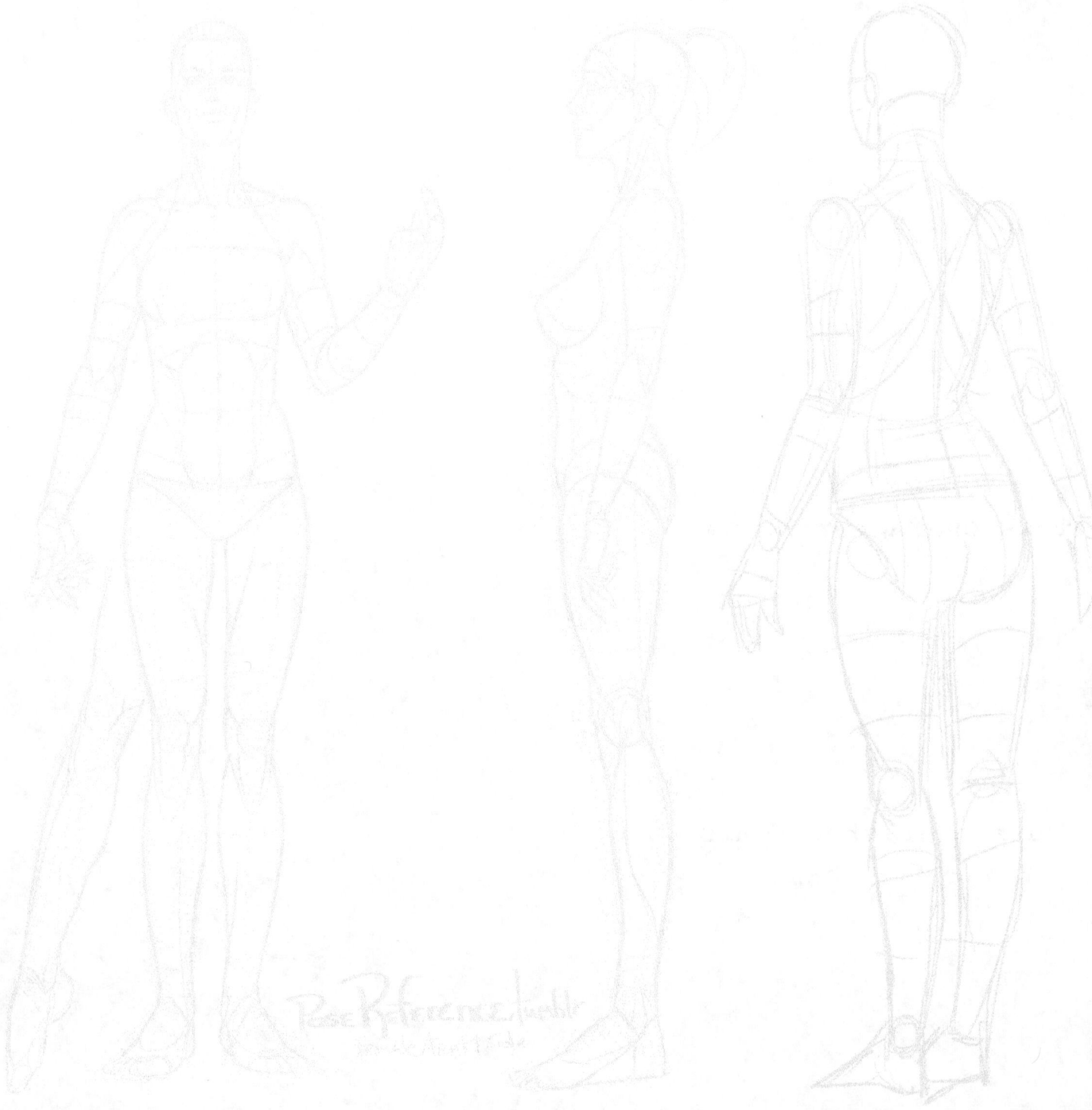

```
NAME:
```

Backstory summary

NAME:

Interesting ideas:

NAME:

NOTES:

NAME:

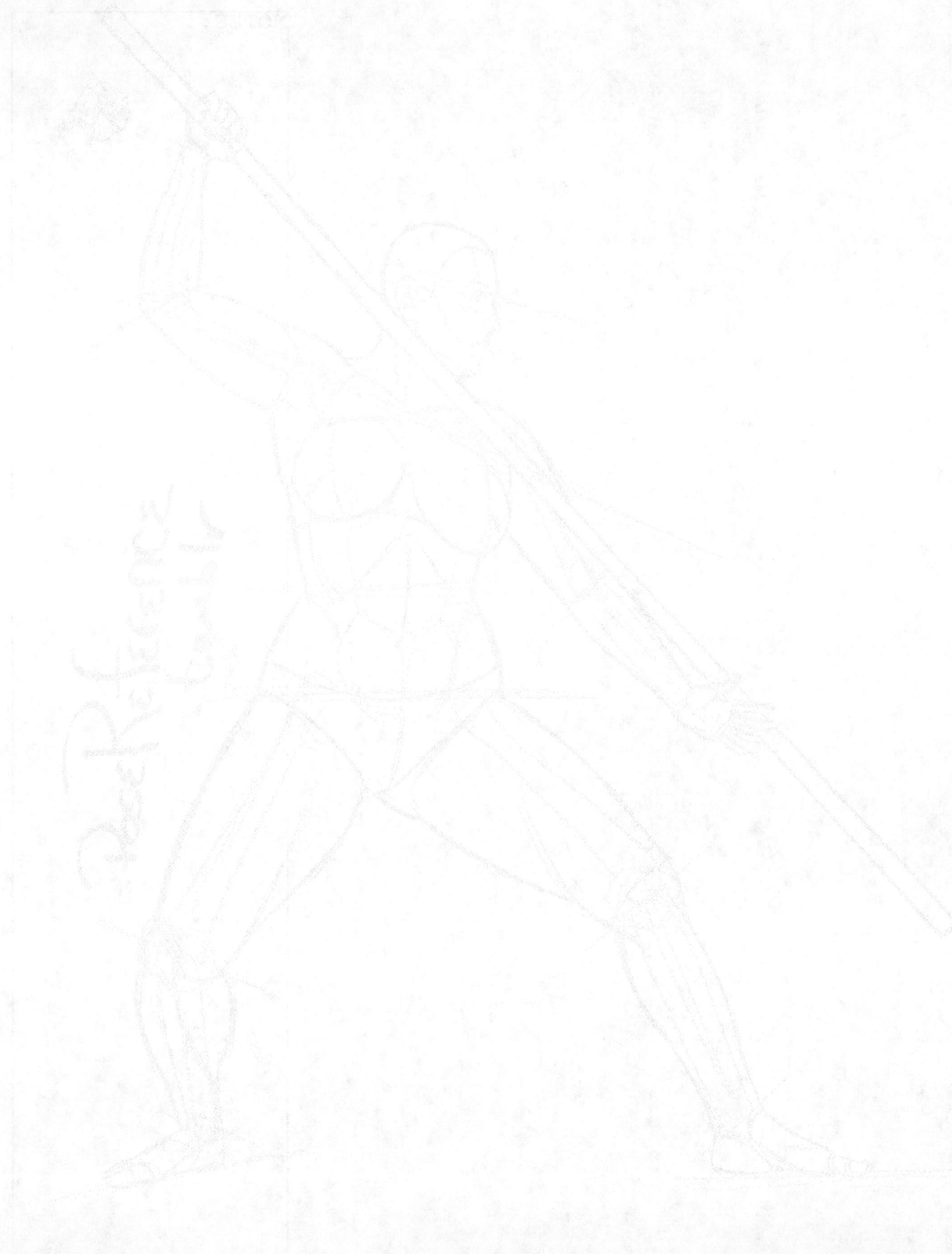

NAME :

SUMMARY AND CONCLUSIONS:

This character is...

This character dreams...

This character loves...

This character fears...

NAME:

13 NAME:
Details:

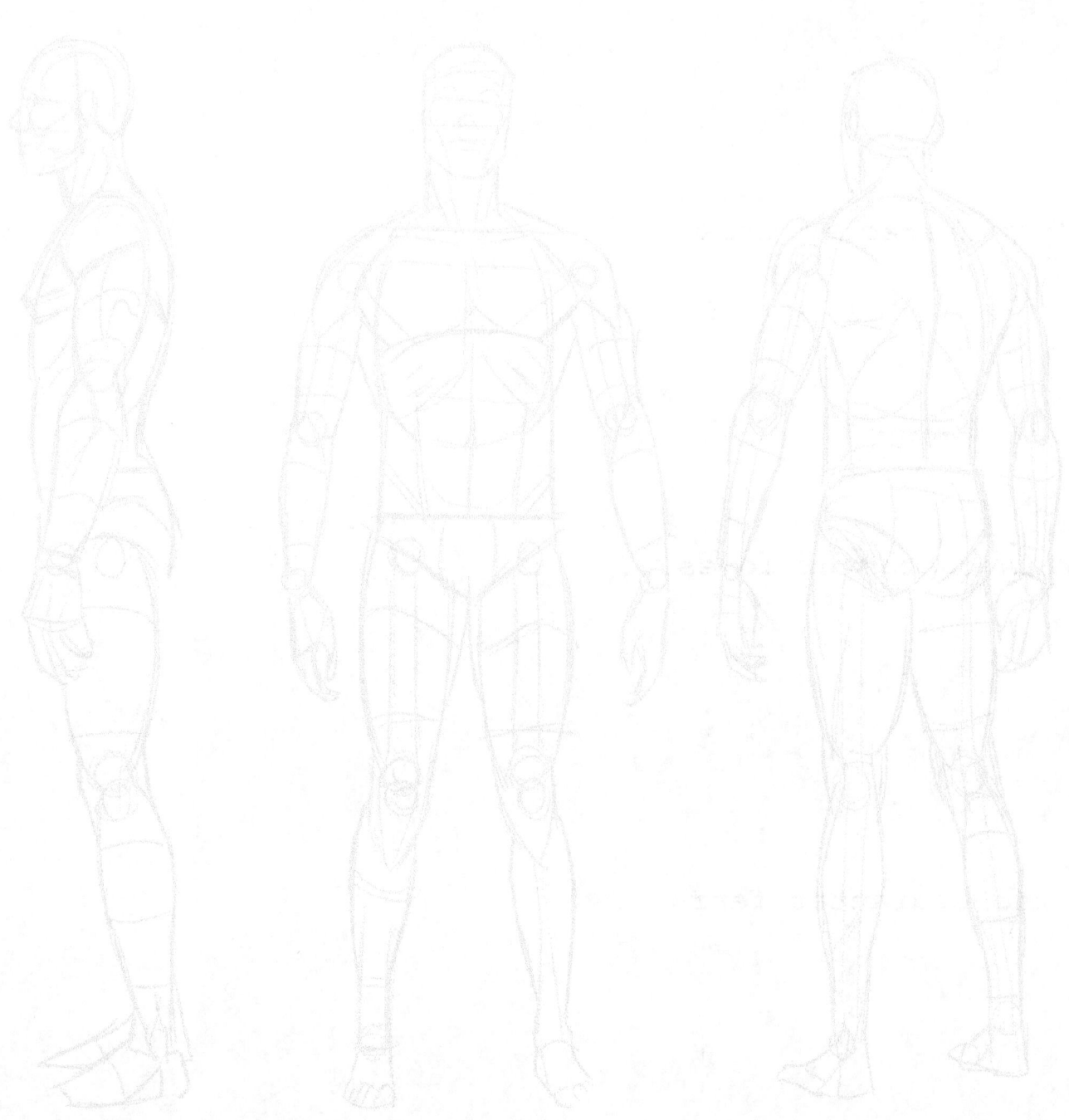

NAME:

Backstory summary

NAME:

Interesting ideas:

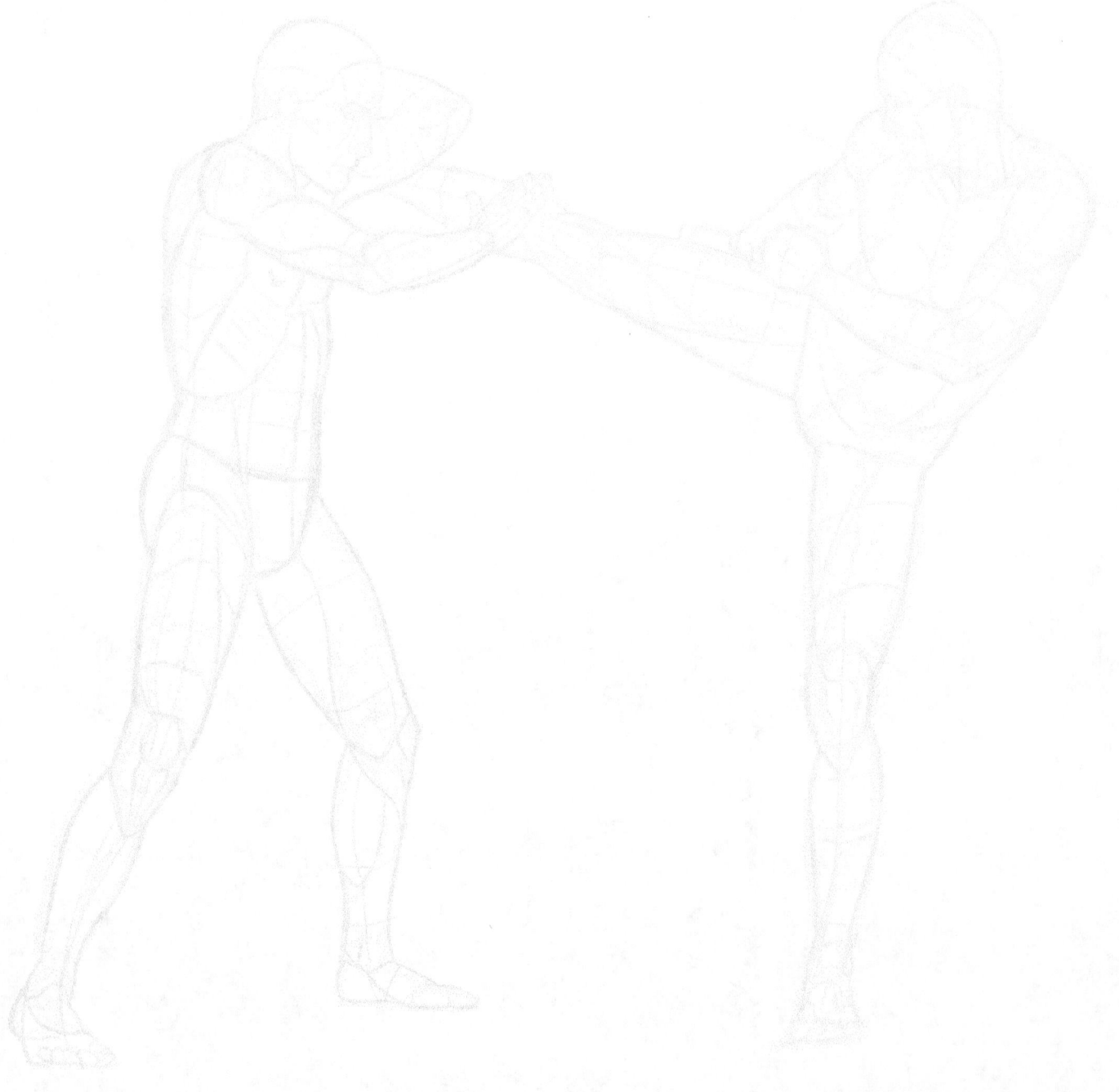

NAME:

NAME:

NOTES:

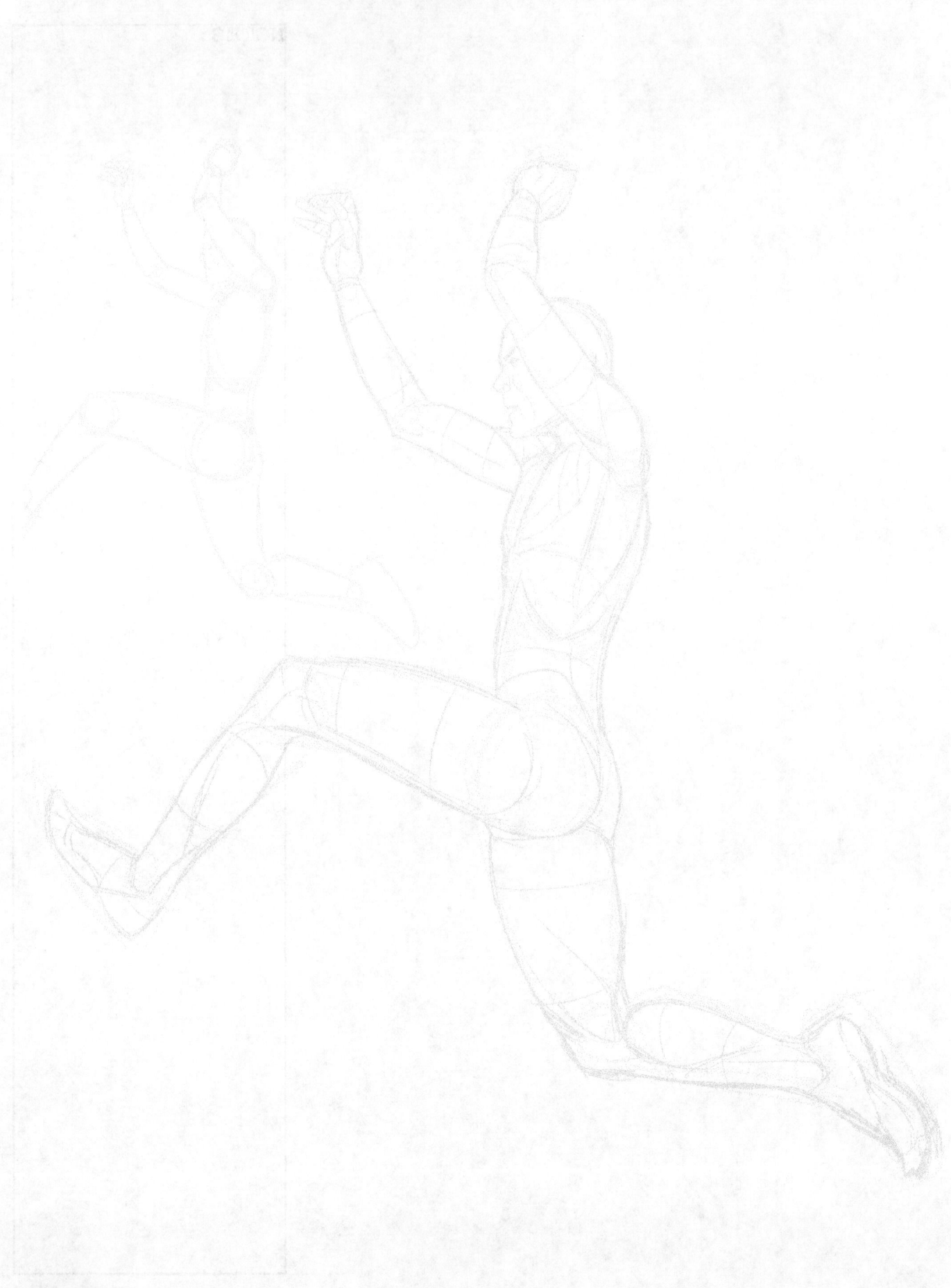

NAME :

SUMMARY AND CONCLUSIONS:

This character is...

This character dreams...

This character loves...

This character fears...

NAME:

14 NAME:
Details:

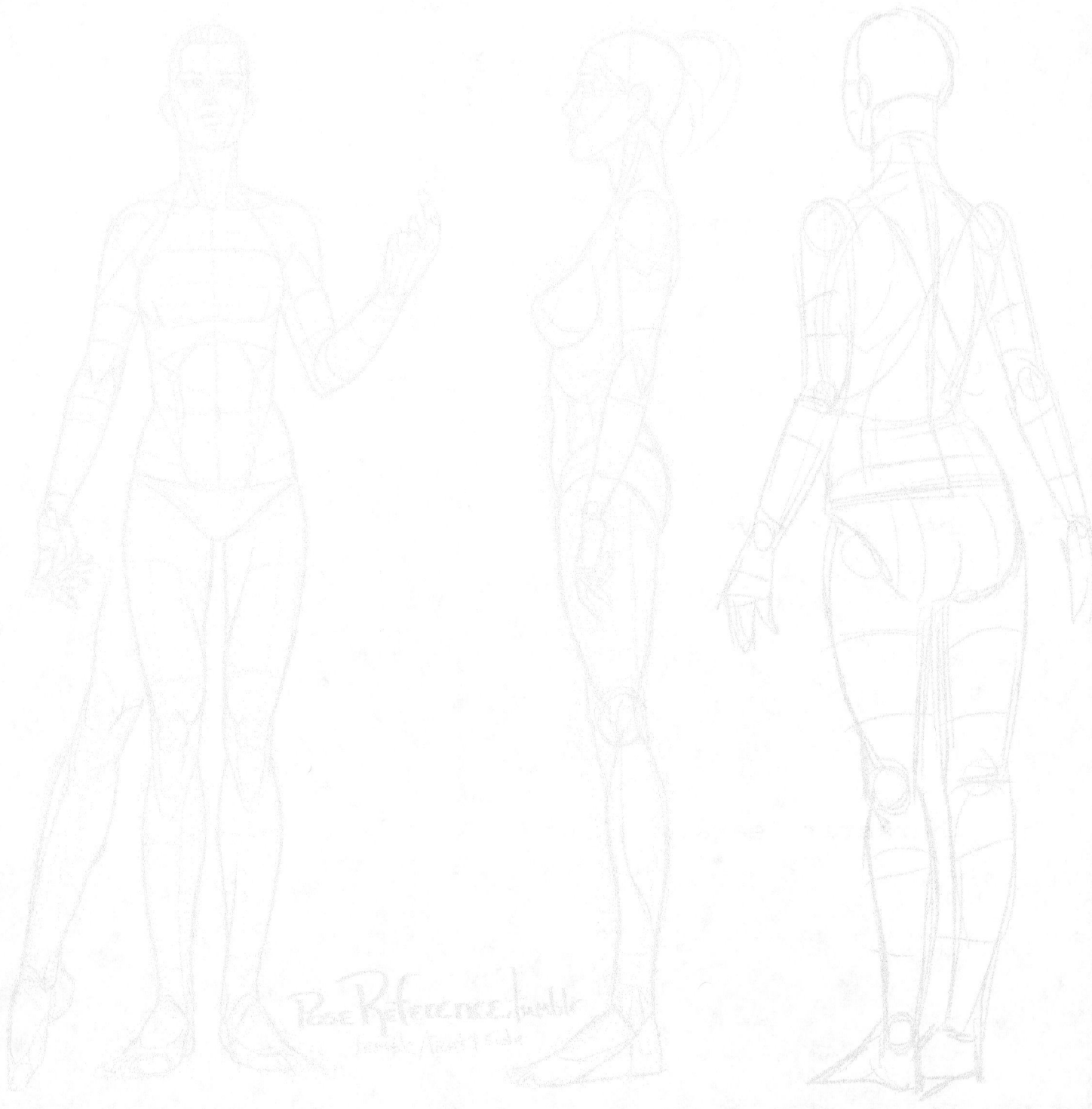

NAME:

Backstory summary

NAME:

Interesting ideas:

NAME:

NOTES:

NAME:

NAME:

SUMMARY AND CONCLUSIONS:

This character is...

This character dreams...

This character loves...

This character fears...

NAME:

15 NAME:
Details:

NAME:

Backstory summary

NAME:

Interesting ideas:

NAME:

NOTES:

NAME:

NAME :

SUMMARY AND CONCLUSIONS:

This character is...

This character dreams...

This character loves...

This character fears...

NAME:

16 NAME:
Details:

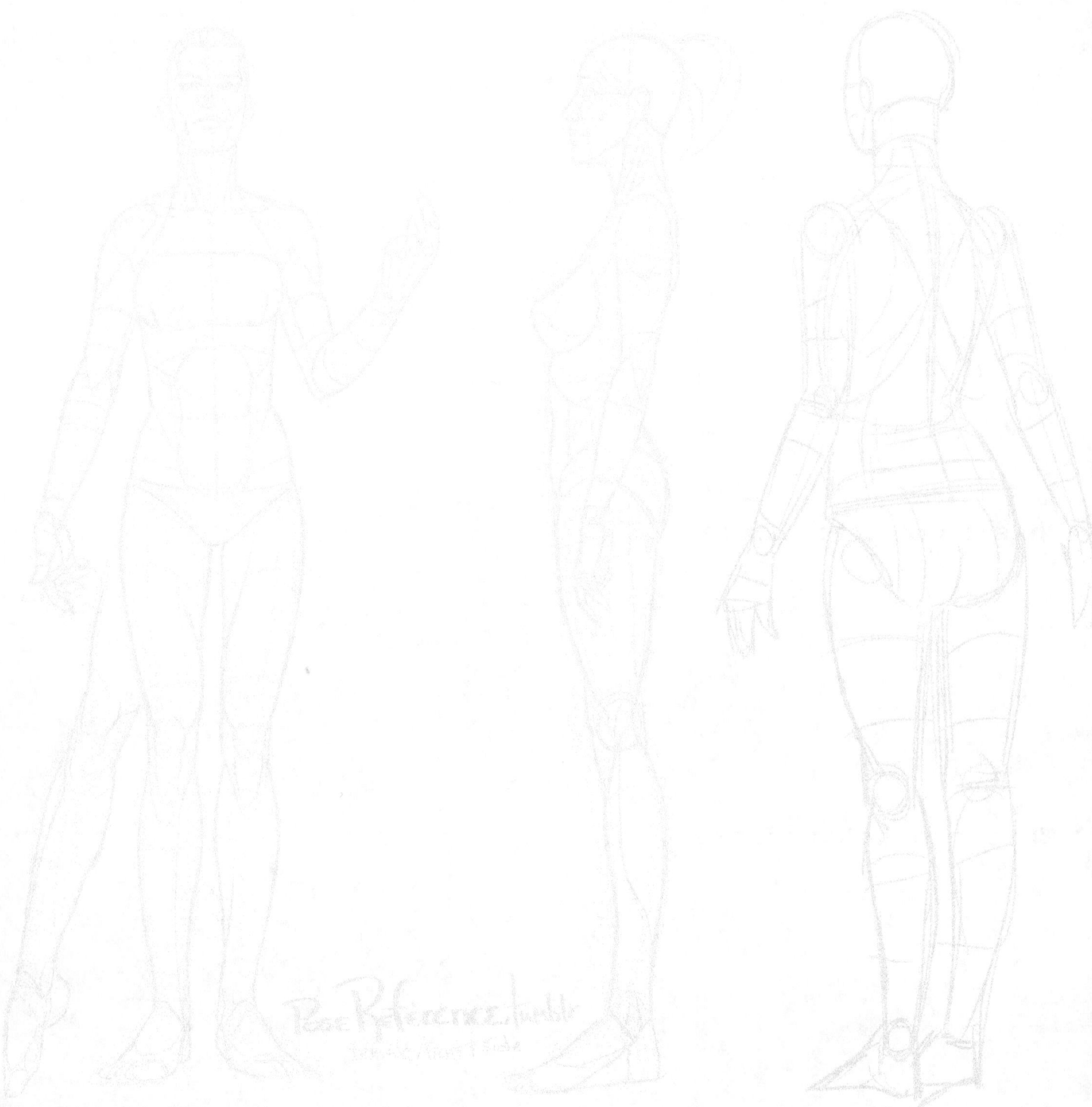

NAME:

Backstory summary

NAME:

Interesting ideas:

NAME:

NOTES:

NAME :

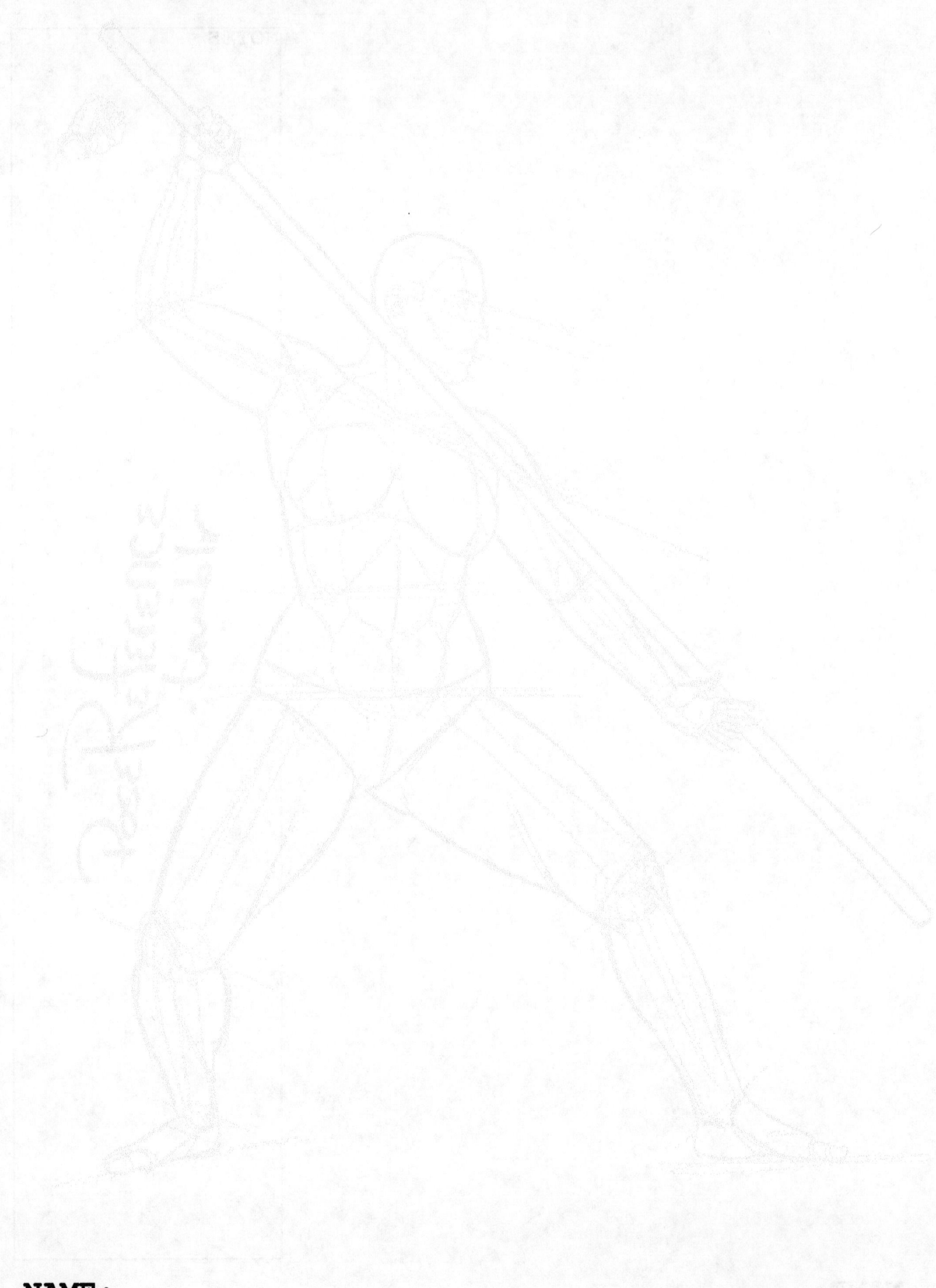

NAME :

SUMMARY AND CONCLUSIONS:

This character is...

This character dreams...

This character loves...

This character fears...

NAME:

17 NAME:
Details:

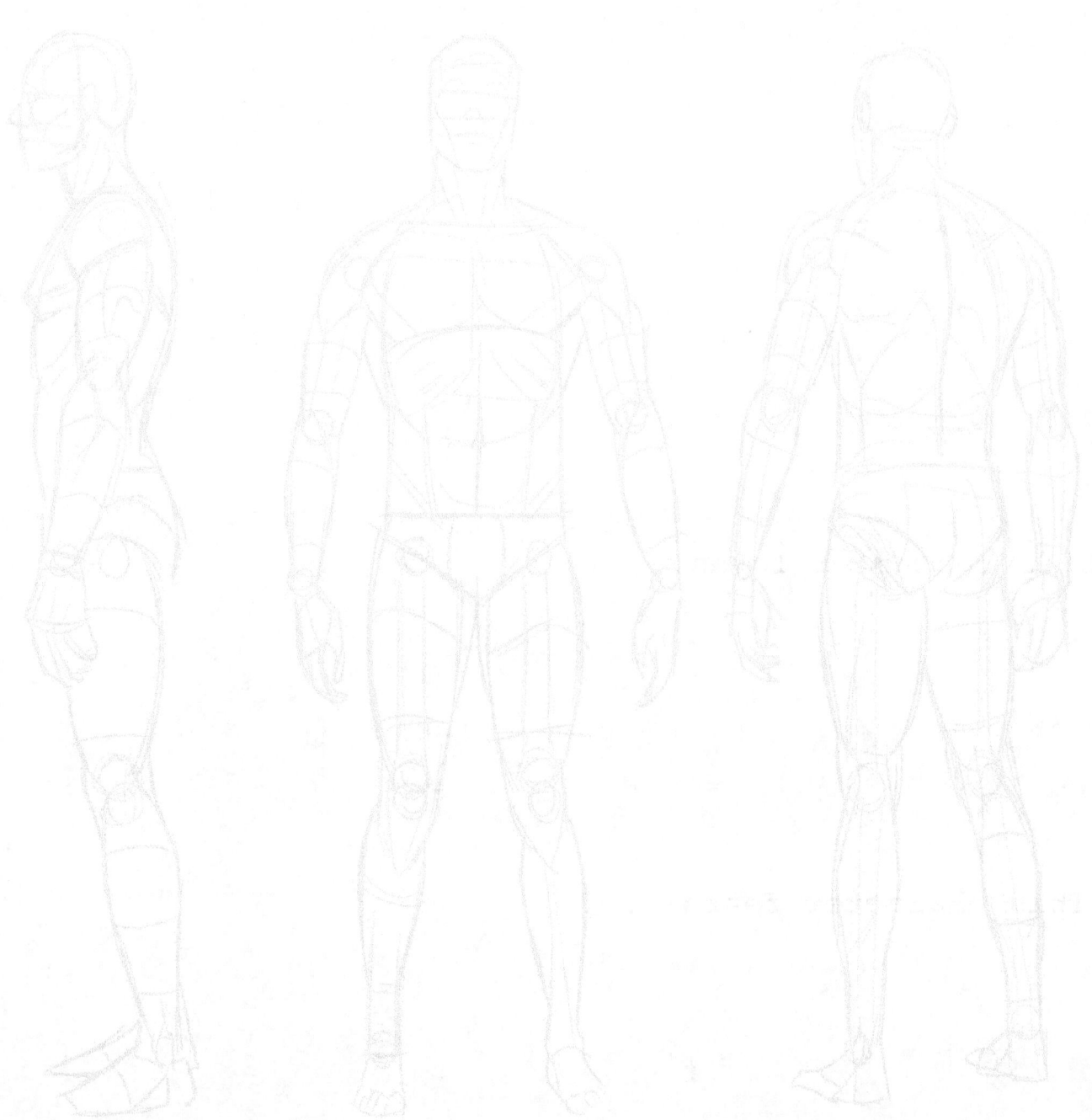

NAME:

Backstory summary

NAME:

Interesting ideas:

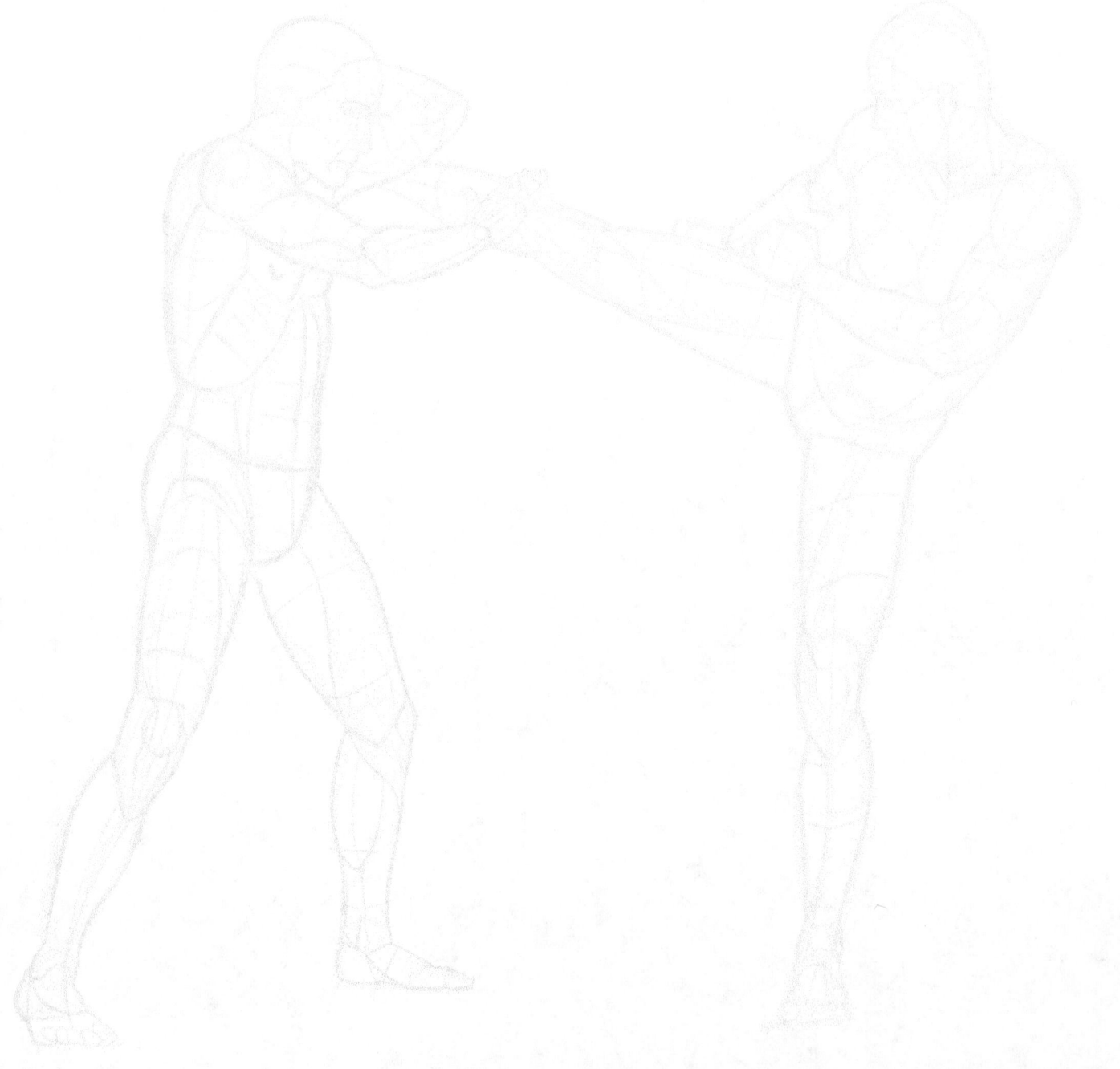

NAME:

NOTES:

NAME:

NAME :

SUMMARY AND CONCLUSIONS:

This character is...

This character dreams...

This character loves...

This character fears...

NAME:

18 NAME:
Details:

NAME:

Backstory summary

NAME:

Interesting ideas:

NAME:

NOTES:

NAME:

NAME :

SUMMARY AND CONCLUSIONS:

This character is...

This character dreams...

This character loves...

This character fears...

NAME:

```
19 NAME:
Details:
```

```
  NAME:
```

Backstory summary

NAME:

Interesting ideas:

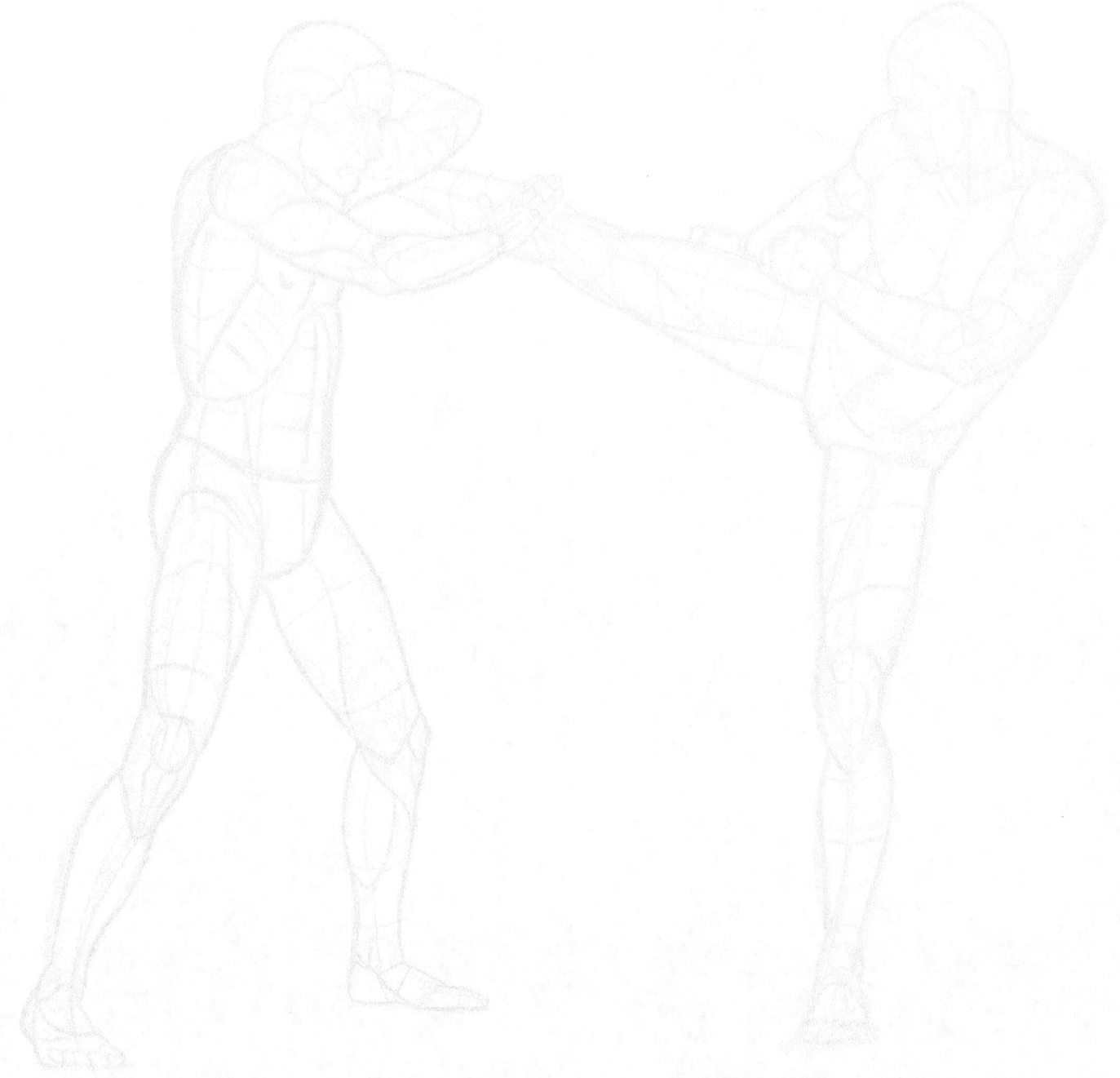

NAME:

NOTES:

NAME:

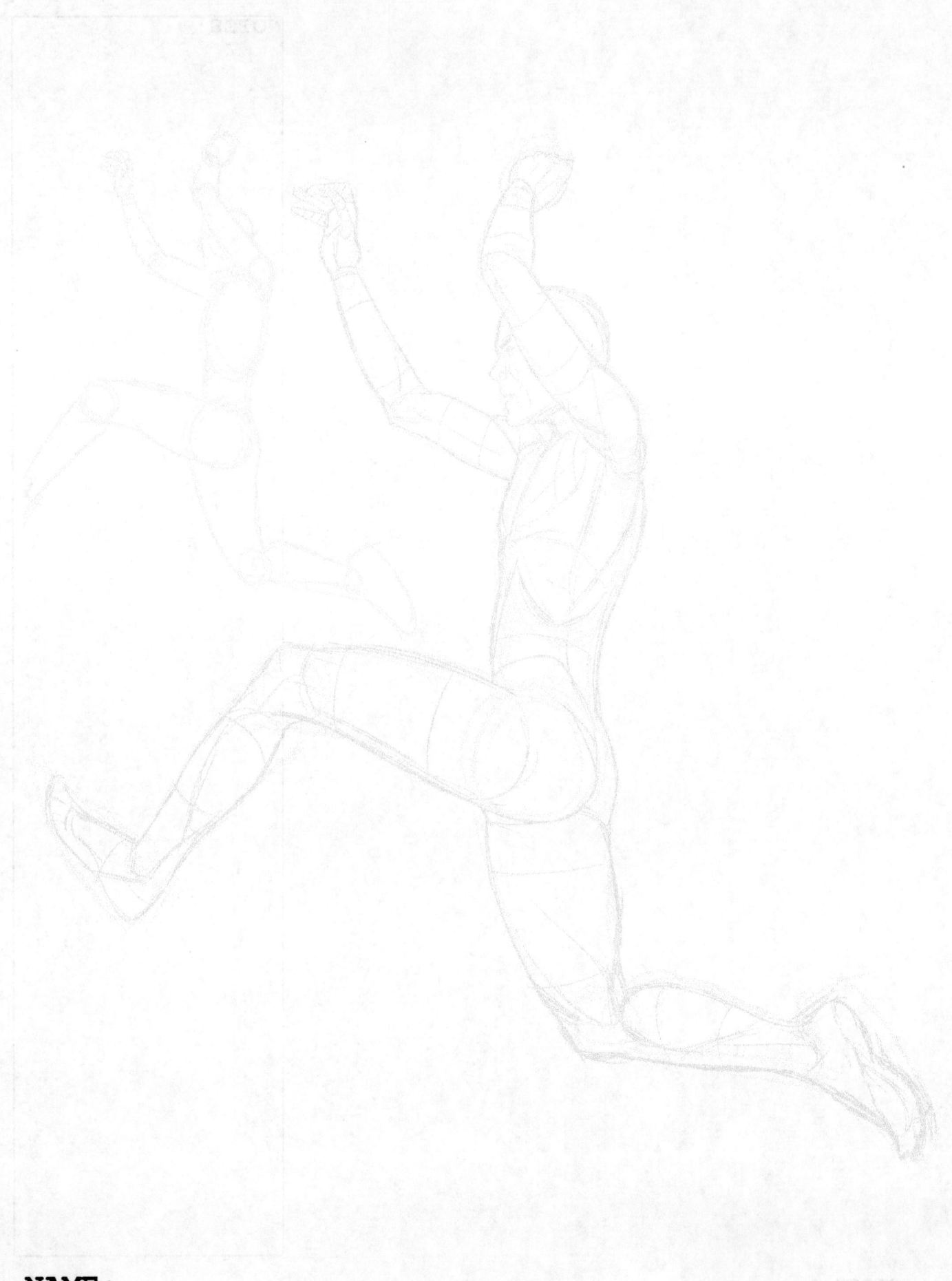

NAME :

SUMMARY AND CONCLUSIONS:

This character is...

This character dreams...

This character loves...

This character fears...

NAME:

20 NAME:
Details:

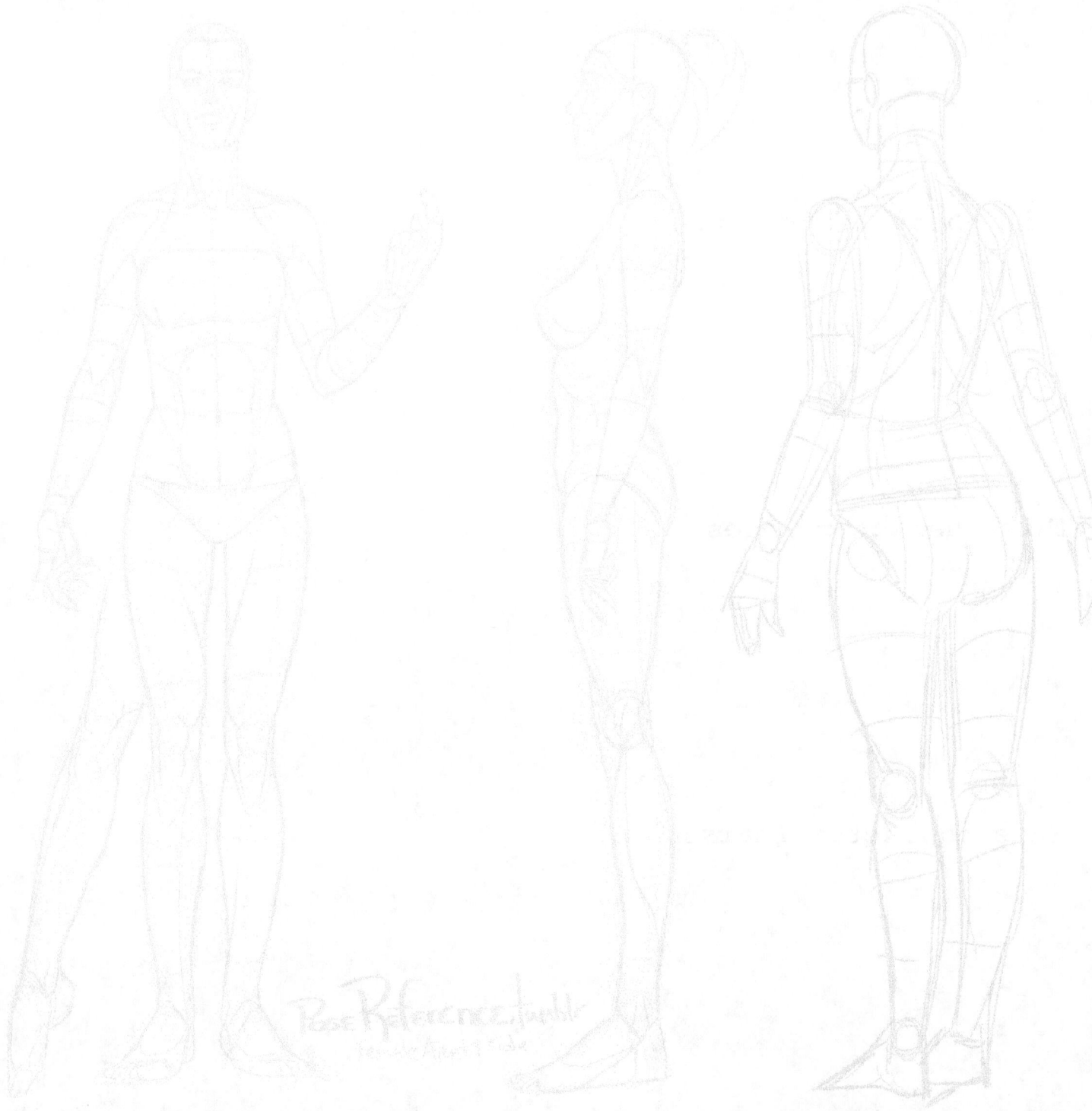

NAME:

Backstory summary

NAME:

Interesting ideas:

NAME:

NOTES:

NAME:

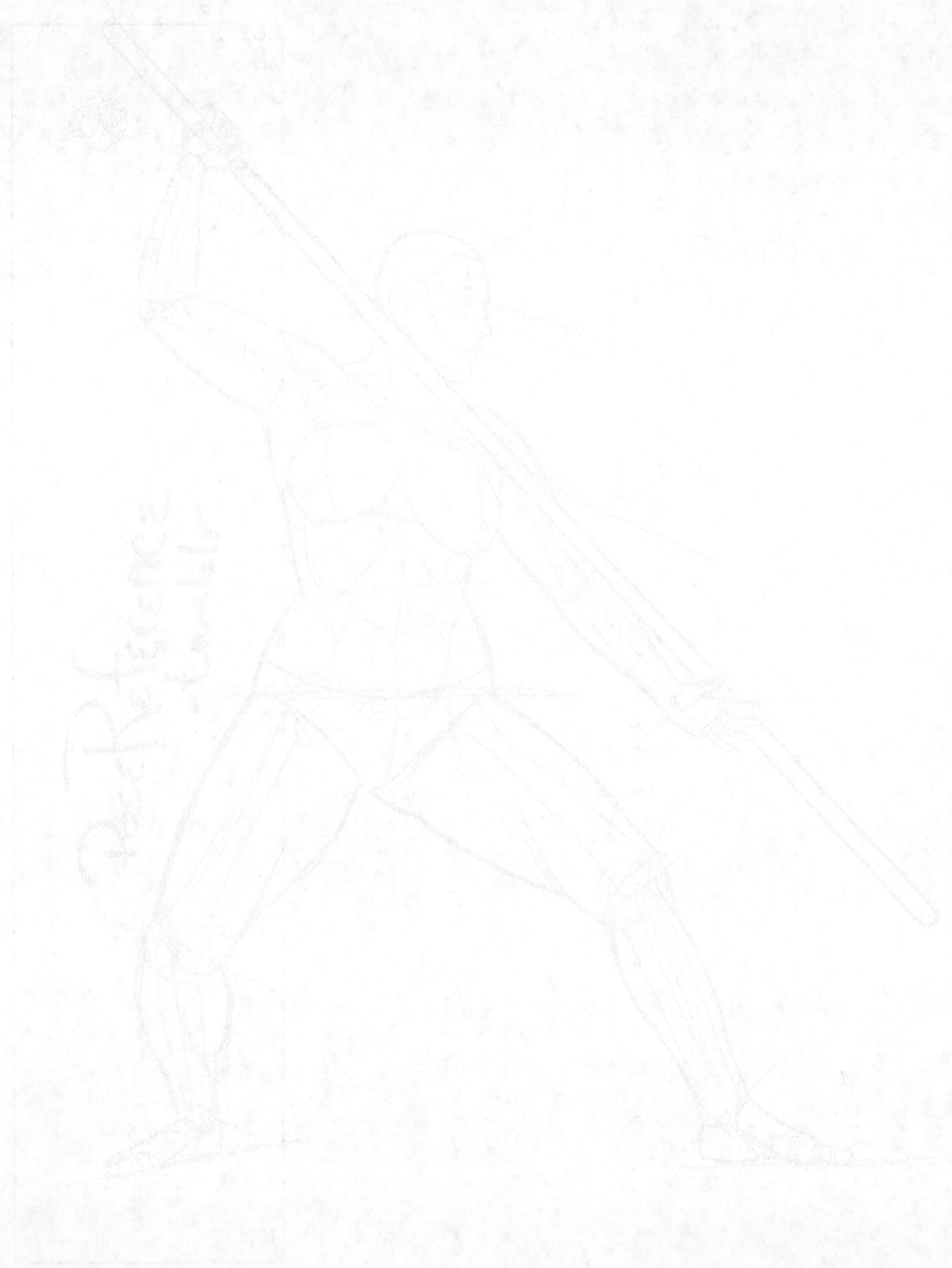

NAME :

SUMMARY AND CONCLUSIONS:

This character is...

This character dreams...

This character loves...

This character fears...

NAME:

Thank You, Links and Important Info

Thank You to everyone who inspired me to use the poses in a way that can really help young
artists capture their ideas in an easy and fun way.

This dossier-style book is something I
REALLY could have used back when I was an
aspiring comic artist and it is a
privilege to have so many artists and creators ask for it.

Thank you Iggy and Ebeth over on
Tumblr.com/draw247 and all the growing community there who pushed for this book.

Our links:

- **www.POSEmuse.com** is our central-portal for all-things we create and post.
- www.tumbr.com/Draw247 for our VERY active group of artists using prompts and poses to make new art.
- www.tumblr.com/posereference - the art-blog that this has all sprung from
- www.patreon.com/poseref

 A big shout-out to August Tarantino, Iggy, Sean Kennedy, Steve Harrison, Tavin Martin, and all the artists who inspire me and have since I first picked-up a pencil

- Justin Martin, July 17th 2016-